Michael Landy H2NY

Michael Landy H2NY

With an essay by Barry Schwabsky

ALEXANDER AND BONIN, NEW YORK
THOMAS DANE GALLERY, LONDON

First published in the United Kingdom
in 2007 by

Alexander and Bonin
132 Tenth Avenue, New York,
NY10011, USA
Tel. +1 212 367 7474
www.alexanderandbonin.com

and

Thomas Dane Gallery
11 Duke Street, St. James's,
London SW1Y 6BN, UK
Tel. +44 (0)20 7925 2505
www.thomasdane.com

To coincide with the exhibition
Michael Landy H2NY
at Alexander and Bonin
20 February to 31 March 2007

Distributed by Ridinghouse
through Cornerhouse
70 Oxford Street
Manchester M15 5NH
Tel.: +44 (0)161 200 1501
www.cornerhouse.org

Great care has been taken to identify
all copyrights holders correctly. In case
of errors or omissions please contact
the publishers so that we can make
corrections in future editions.

Photography
London: Thierry Bal, Hugh Kelly
and Todd White Photography
New York: Bill Orcutt

Special thanks to Alice Chubb,
Ariel Phillips and Leigh Robb

ISBN 978-1-905464-07-4

Designed by Peter Willberg
at Clarendon Road Studio

Printed in Germany by
Offizin Scheufele, Stuttgart

Content

A Rousing Cheer for the Dying Monster

Barry Schwabsky

In the 1965 compilation film *Paris vu Par…*, Jean-Luc Godard's episode "Montparnasse-Levallois" (in collaboration with Albert Maysles) updated a Guy de Maupassant story about a two-timing girl who accidentally sends a note meant for one boyfriend to her other beau. And no wonder she mixes them up; boyfriend A is an artistic, a sculptor, who affects the ways of a mechanic; boyfriend B is a mechanic who gives himself the airs of an artist. I've sometimes wondered whether the first boyfriend might have been modeled on Jean Tinguely, and after a couple of looks at D.A. Pennebaker's *Breaking It Up at the Museum*, 1979, filmed in New York in 1960 on the occasion of Tinguely's *Homage to New York*, watching him work away with his acetylene torch, I'm almost sure of it. But then, like the girlfriend played by Joanna Shimkus, I'm not sure which he's more like, the artist who would be a mechanic or the mechanic who would be an artist. If Tinguely is a somewhat overlooked figure in the history of post-war art, it's probably because in his work and in his disposition as an artist, he looks backwards and forwards, making him hard to categorize. On the one hand, he was close in method to the "junk sculptors" and assemblagists of the '50s, such as the American artist Richard Stankiewicz, but on the other, to the antic spirit of Fluxus and to the "dematerializing," anti-object trends of the '60s.

A good deal of Michael Landy's recent work has been concerned with his parents. *Semi-Detached*, 2004, an installation at the Tate Britain, was a full-sized copy of Mr. and Mrs. Landy's home in Essex; later that year, at the Thomas Dane Gallery in London, he showed "WELCOME TO MY WORLD—Built with you in mind," which included numerous portrait drawings of his father, rendered with a meticulously linear realism; the other works in the show were drawings, a video, and a collage representing objects that form part of John Landy's daily life as well as a photograph of the elder Landys standing in front of their son's monumental work at Tate Britain.

In 1959, Tinguely addressed an audience at the ICA in London with a discourse they could not understand, since he did not speak directly but played a recorded speech, in poor English, on two tape recorders running slightly out of phase, "thus

setting up," according to Calvin Tomkins, whose account of *Homage to New York* and the events leading up to it is still the most comprehensive available, "a chaotic babble that most of the audience found incomprehensible but sidesplitting." Something was communicated, just not in the usual manner. His work had begun with a love of movement, and *therefore* a fascination with the machine (and not with an interest in the machine as exemplar of efficiency, as was the case with his Swiss forerunner, Le Corbusier). Tinguely's investigation of movement had shown him that destruction was its logical conclusion—and a source of all potential further movement. In Tinguely's written text for the ICA, the lesson his work held for him is patent: "To attempt to hold fast an instant is doubtful. To bind an emotion is unthinkable. To petrify love is impossible."

Having meditated in his art on the life of his father, it seems that Landy has now turned his thoughts to one of his artistic progenitors. To Tinguely, of course, his family resemblance is patent. Landy's best known work remains *Break Down*, 2001, which involved systematically destroying his every possession (including, as many reviews and articles at the time pointed out, the jacket he'd been handed down from his dad). Although that project had unique aspects that make it quite distinct from any precedent, it was nonetheless clearly in the tradition of what Gustav Metzger called, quite simply, "destruction in art" or "auto-destructive art." Metzger, a German-Jewish émigré, worked (as he continues to do) in England, so it might seem surprising that Landy has, so to speak, gone abroad to find his elective precursor in Tinguely, a Swiss in Paris who began working with destruction as a form of creation at about the same time as Metzger. The reason for Landy's choice must have something to do with the fundamental difference between the two elders: Metzger's is essentially an art of protest, while Tinguely's is one of celebration.

It took Tinguely three weeks to build his *Homage to New York,* the most famous of his machines that destroyed themselves; it took the thing (starting about an hour behind schedule) only 27 minutes to self-destruct. Its materials: a quantity of old motors, a weather balloon, rusty bicycle and baby carriage wheels, the drum from a washing machine, a child's potty and bassinet, a large roll of paper, a fan, a piano, an addressograph machine, saws, a radio, a couple of the artist's own "Meta-Matics," machines set up to automatically produce abstract paintings by the foot—and much, much more besides, mostly salvaged from scrap yards or acquired on the cheap from sources like the stores along Canal Street, and all visually unified with

a coat of white paint. "We can put anything into the machine," a rapturous Tinguely told Billy Klüver, who was acting as his assistant, though the latter knew that this expression of wild optimism was unfounded. "I thought only dreamers destroyed themselves," is what Anaïs Nin later claimed to have remarked when she was invited to the Museum of Modern Art's Sculpture Garden on March 17, 1960, to see Tinguely's *Homage* in action.

Landy has determined to make a sort of homage to *Homage to New York*, perhaps even a sort of reincarnation of it (for Tinguely always spoke of his creation as a living thing, as a person: In *Breaking It Up at the Museum* he calls *Homage* something that "makes pictures, a componist [he means composer], a poet"). Just as Tinguely had to begin by gathering materials, Landy has had to begin by assembling information. Drawing then functions as a sort of internalization or appropriation of the evidence, though what emerges most vividly from Landy's drawings from photographs of the event is a sense of the glare of lights through the smoke as they reflect off the white-painted machine. In some of these drawings (for instance, *H2NY The Constructive Destruction of a Destructive Construction* [p.23]) the machine is transformed into a labyrinth of bright lines; space becomes distorted as the highly detailed schematic rendering simultaneously maps out a perspectival space and collapses it into flatness. Elsewhere, as in *H2NY Self Destroying Work of Art* (p.41), the rendering is more realistic, especially when Landy uses a range of tonalities, allowing for some shades of gray between the extremes of white and black. *H2NY Self-Destroying Sculpture Garden* (p.36), with its inserted images of the Garden's statuary—Rodin, Maillol, and the rest—and explanatory texts, becomes a sort of cartoonist's key to an imagined event. Here and there we catch sight of Tinguely at work, helping his mechanical creature along to its fate, but the public is there too, if only as the negative silhouettes revealed by the spray of light as it refracts through the smoke (*H2NY The Audience Gave a Rousing Cheer for the Dying Monster* [p.59]).

Just as some of Tinguely's other self-undermining machine-spectacles "failed to fail," in Tomkins' resonant phrase, the suicide of *Homage to New York* was a harder job than expected, and the thing finally had to be helped out of its misery. Anaïs Nin: "Clattering, steaming, hiccoughing, vibrating, puffing, hissing, juggling, dislocating, trembling, the entire structure went into a spasm which opened the bottles of chemicals, and they exploded into colored smoke which filled the balloon

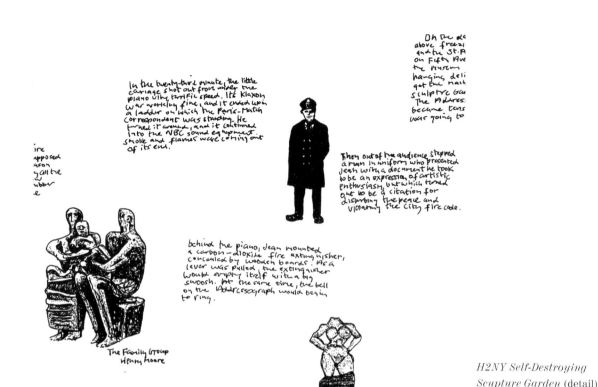

In the twenty-third minute, the little carriage shot out from under the piano with terrific speed. Its klaxon was working fine, and it ended up on a ladder on which the Paris-Match correspondent was standing. He turned it around, and it continued into the NBC sound equipment. Smoke and flames were coming out of its end.

ire supposed ason g all the ubbe e

behind the piano, Jean mounted a carbon-dioxide fire extinguisher, concealed by wooden boards. As a lever was pulled, the extinguisher would empty itself with a big swoosh. At the same time, the bell on the Addressograph would begin to ring.

The Family Group Henry Moore

Oh the ds above freezi and the St. A on Fifth Ave the museum hanging deli got the mash sculpture gar The Addres: became tens was going to

Then out of the audience stepped a man in uniform who presented Jean with a document he took to be an expression of artistic enthusiasm, but which turned out to be a citation for disturbing the peace and violating the city fire code.

H2NY Self-Destroying Scupture Garden (detail) 2006

with air, set the roll of pare unrolling and the brush painting erratically…. The piano started to burn slowly, and as it burned the notes played wistfully, out of tune, unreal, like a pianola. The flames consumed the wood but not the notes and not the wires." This is the *Homage to New York* I seem to describe through Landy's drawings, rather frightening and haunted, rather than the more good-humored creature that emerges from Tomkins' account.

What spectacle Landy's efforts will all result in remains, as I write, unknown. How close will it be to the one a couple of hundred people witnessed forty-seven years ago? It's hard to say. The basic facts about Tinguely's work are well known, but because the machine itself no longer exists and the people most closely connected with it no longer living, the details are often obscure. Although the thing that he builds may well look something like Tinguely's *Homage*, there still remains the fact that since the workings of the machine were improvised—Tinguely was more of an Abstract Expressionist, after all, than we think—it is quite impossible that the sequence of movements produced by the reconstruction to follow those of the original. Whether or not it can be considered a new creation, it will surely be a new destruction.

Contrary to how it appeared to spectators at the moment—and to some subsequent accounts, including Nin's eyewitness memoir—the New York Fire Department did not summarily and unilaterally intervene to administer the coup de grace when the apparatus refused to expire as expected. It was the artist himself, according to Tomkins, who "suddenly began to worry for fear that the fire extinguisher in the piano would explode from the heat," and wanted the fire that had overtaken his contraption put out, and it was at the behest of Klüver that a fireman, "with apparent reluctance," instructed some museum guards to put out the blaze, to the jeers of the audience. I wonder if this external, as it were, inorganic ending is not the underlying reason certain observers, acknowledging the sense of joy and freedom at play in *Homage to New York*, finally observed that there was nonetheless something "sad" or "tragic" about it. "One woman told me later," said Tinguely, "that she had wept, she found it so sad." The sadness occasioned by *Homage to New York* must have been a feeling having to do with a sense that the machine finally met an alien death rather than the one it sought for itself.

Aside from factual concerns—significant enough to Landy, it seems to me—there are also deeper, more inchoate concerns to be considered about what's involved in re-presenting an ephemeral thing from the past. Tinguely himself was a proponent of the Heraclitean notion that flux is the underlying reality, that change is the only constant. Is Landy trying to do just what Heraclitus said no one can do—step into the same river twice? We could perhaps defend Landy's effort by pointing, as Freud would have us do, to the pleasure principle, whose condition is nothing other than repetition. In any case, the contradiction between (Heraclitean, Tinguely-esque) difference and (Freudian, Landy-esque) repetition is more apparent than real, since change is only measured by an imagined standard of sameness. It is precisely by reconstructing *Homage to New York* that one could show that *Homage to New York* is unique and unrepeatable and for that reason a font of endless potential difference. Besides, Landy's reconstruction differs from most replicas of lost or destroyed artworks in that it is not meant to preserve its model. On the contrary, it is meant to imitate the original precisely in attempting to destroy itself. Once it does, it too will become an irrecoverable bit of history. It will be exactly like *Homage to New York* precisely through its absence. Only the memories—and the documentation—will be different.

H2NY Picture-Making Machine 2
2006
Oil stick on paper
152 × 122 cm. / 59⅞ × 48 in.

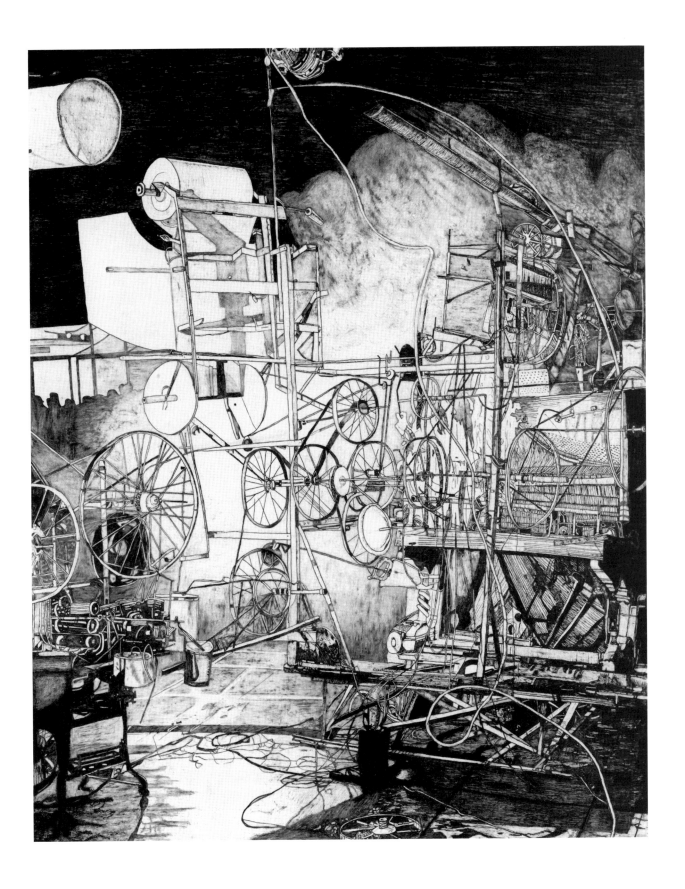

H2NY Tinguely's Contraption, Nation
2006
Oil stick on paper
101.5 × 67 cm. / 40 × 26½ in.

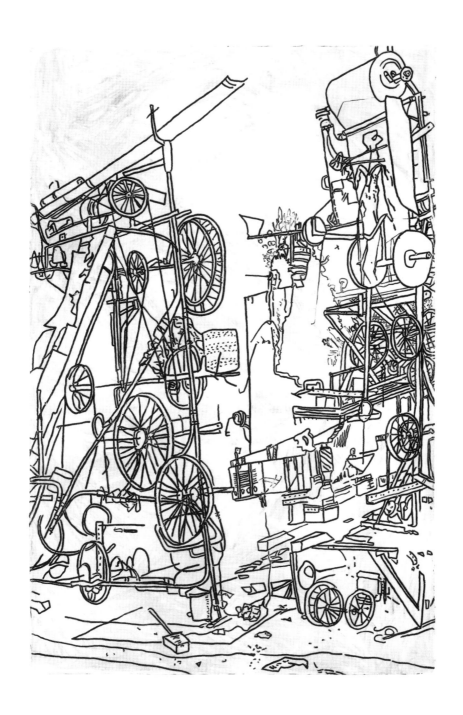

H2NY Self-Constructing, Self-Destroying
2006
Oil stick on paper
152.5 × 122 cm. / 60 × 48 in.

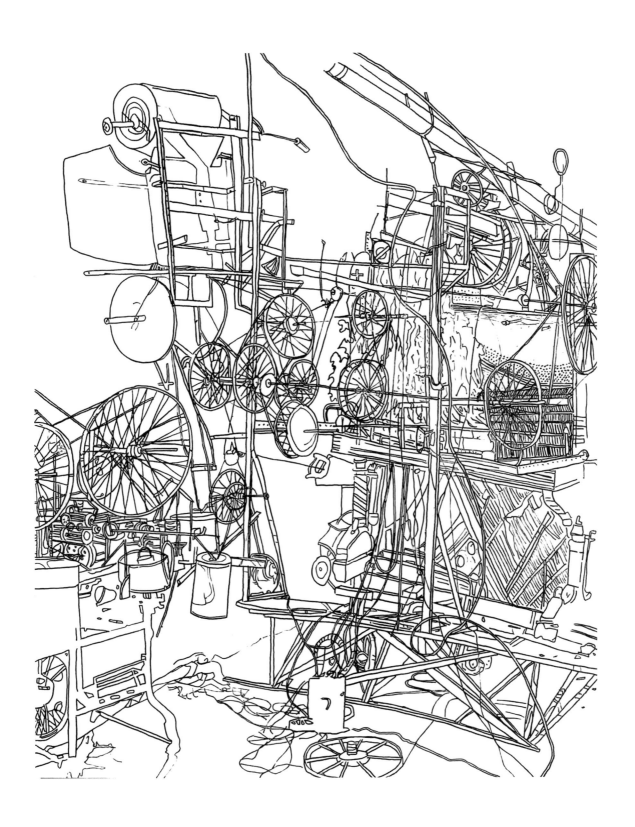

H2NY Self-Destroying Contraption Breaks Down
2006
Glue and gouache on paper
152 × 122 cm. / 57⅞ × 48 in.

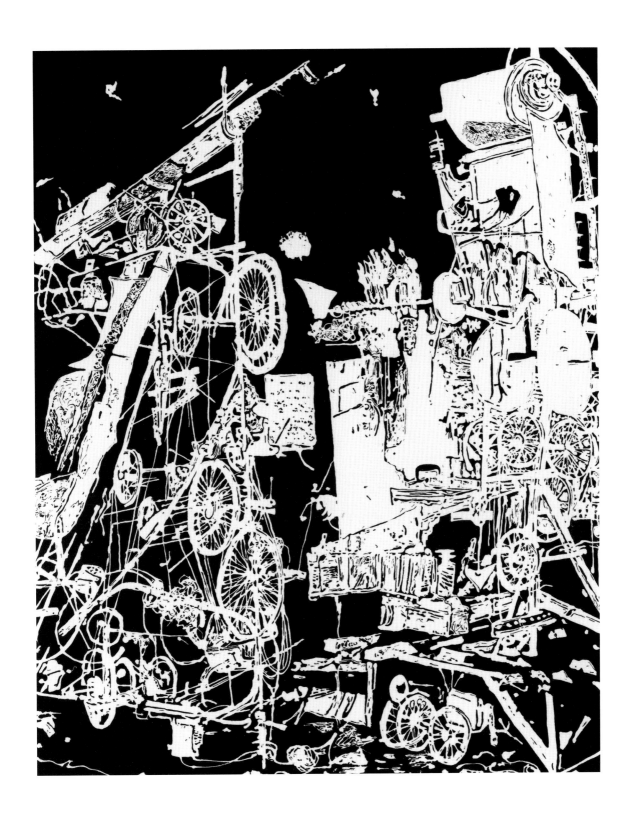

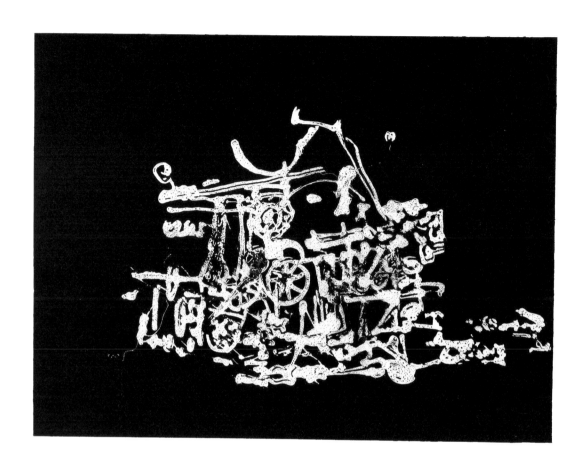

H2NY Choreographed Demise
2006
Glue and gouache on paper
30.6 × 40.6 cm. / 12 × 16 in.

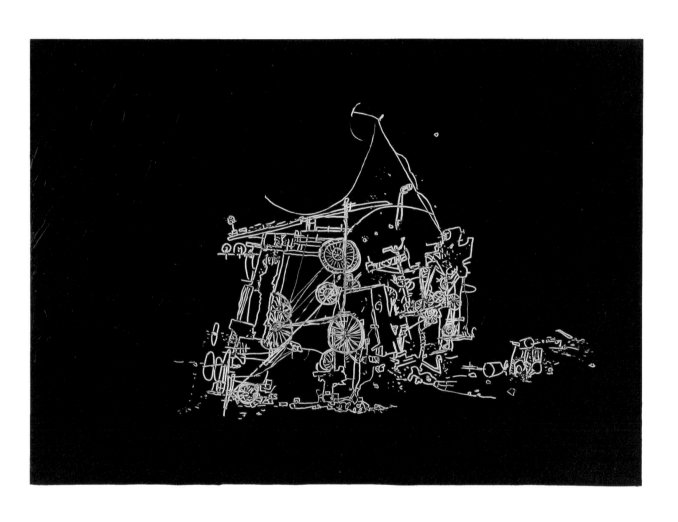

H2NY The Tinguely Machine, The Village Voice
2006
oil stick on paper
59.2 × 84 cm. / 23¼ × 33 in.

H2NY The Constructive Destruction of
a Destructive Construction
2006
Oil stick on paper
137 × 101.6 cm. / 54 × 40 in.

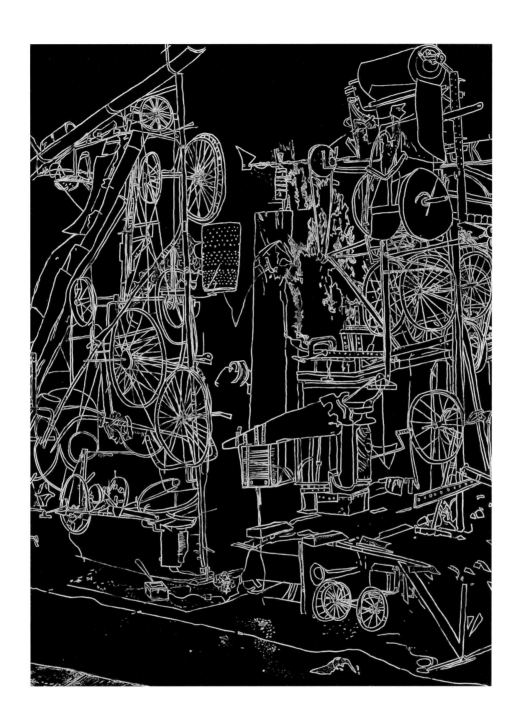

H2NY Blazing Sculpture 'Watered Down',
The Stars and Stripes
2006
Oil stick on paper
122 × 153 cm. / 48 × 60 ¼ in.

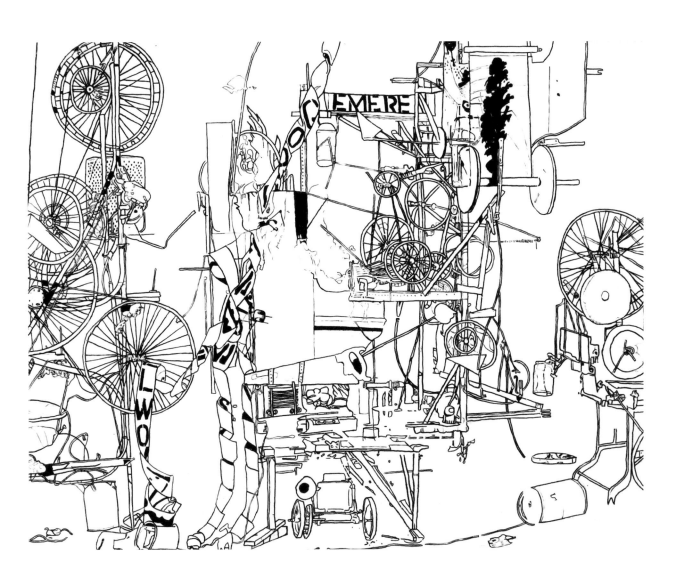

H2NY Mr. Tinguely Makes Fools of Machines
2006
Glue and gouache on paper
101.6 × 66.7 cm. / 40 × 26¼ in.

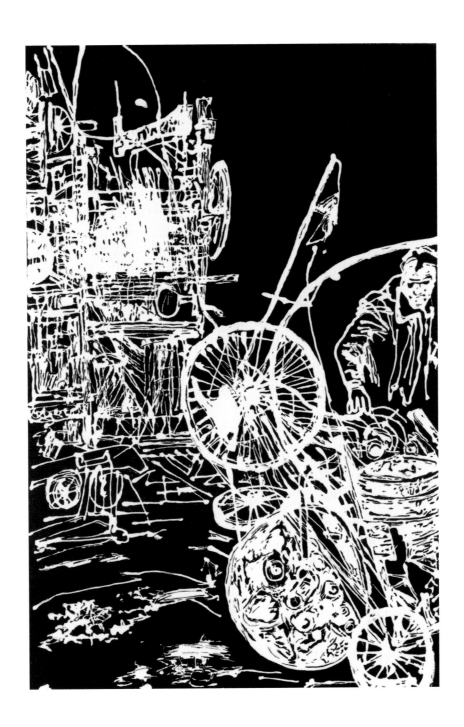

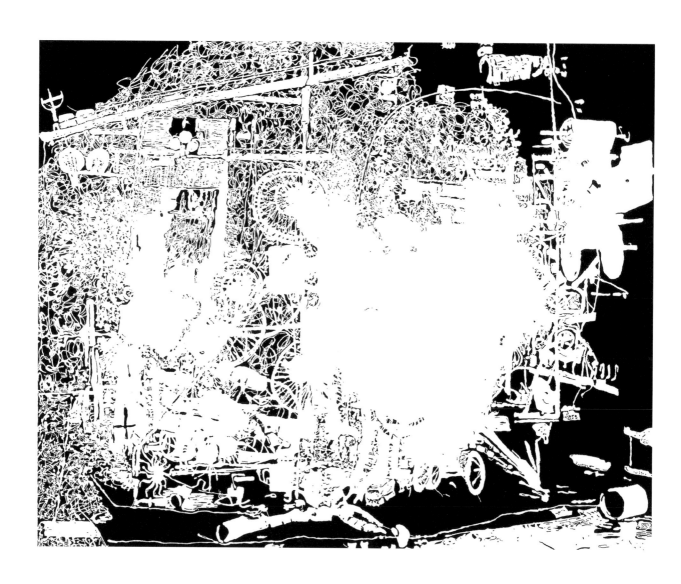

H2NY Kinetic Apparition
2006
Glue and gouache on paper
122 × 152.5 cm. / 48 × 60 in.

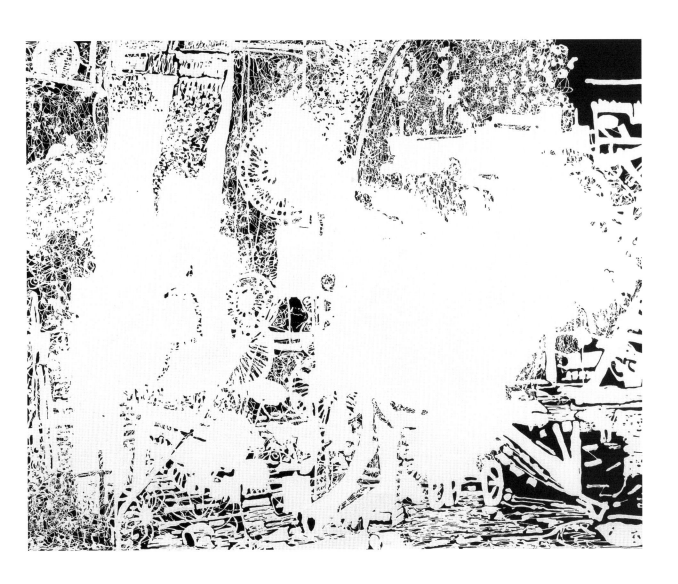

H2NY Autodestructive Suicide at the Garden
2006
Glue and gouache on paper
122 × 152.5 cm. / 48 × 60 in.

**H2NY Suicide Carriage Breaks Down on
its Way to Down Itself in Maillols, The River**
2006
Charcoal on paper
220 × 137.5 cm. / 80⅝ × 54¼ in.

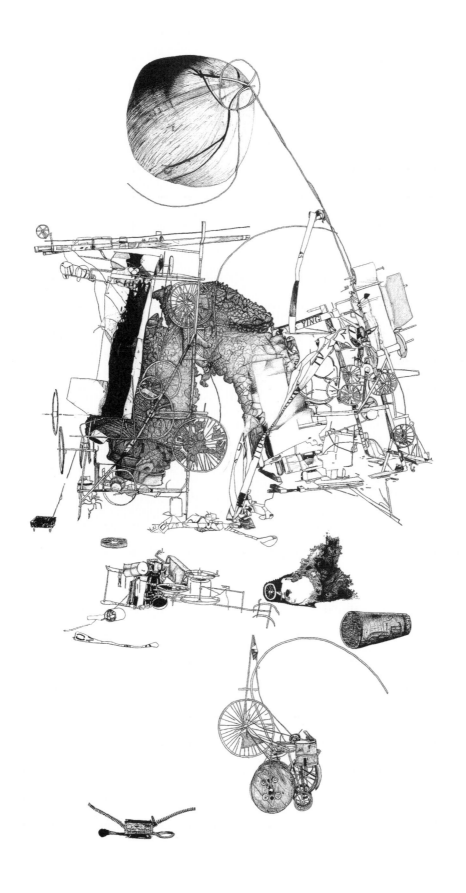

H2NY Burning Piano
2006
Glue and gouache on paper
67.5 × 102.5 cm. / 26½ × 40⅜ in.

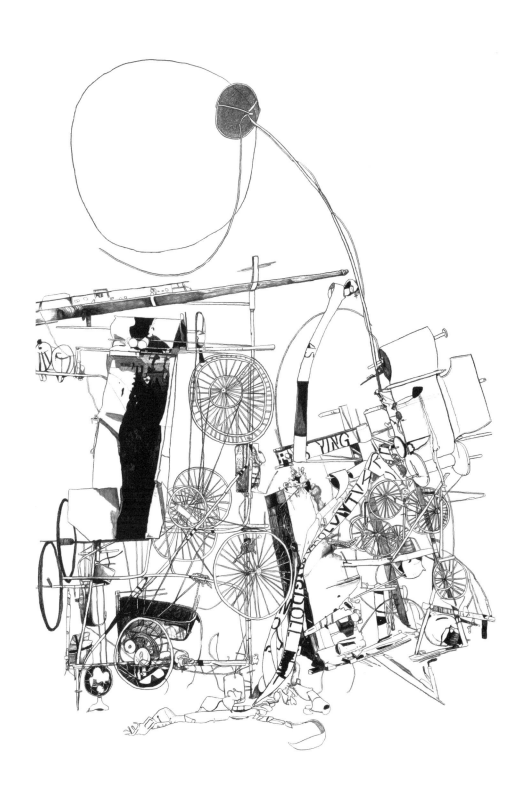

H2NY Self-Destructing Suicide Machine
2006
Charcoal on paper
234 × 150 cm. / 92 × 59 in.

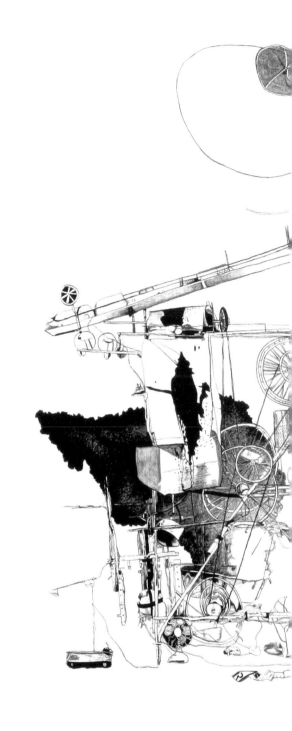

H2NY Self-Constructing, Self-Destroying Machine
2006
Charcoal on paper
150 × 218.5 cm. / 59 × 86 in.

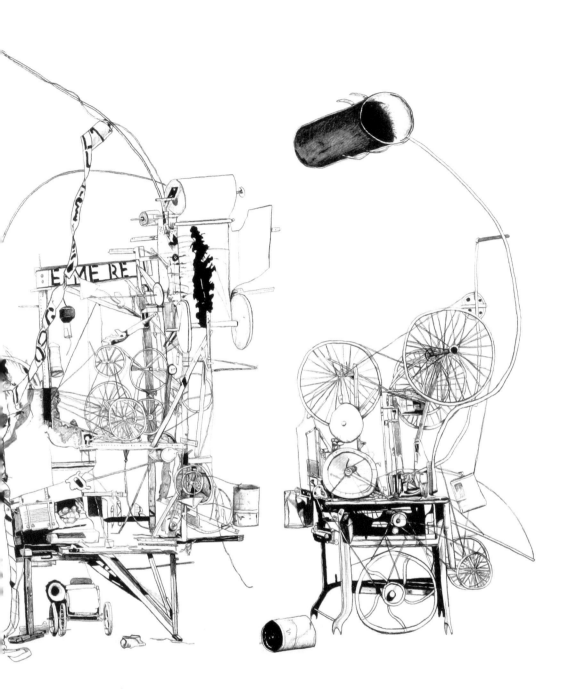

H2NY Self-Destroying Scupture Garden
2006
Ink on paper
70 × 81 cm. / 27½ × 31⅞ in.

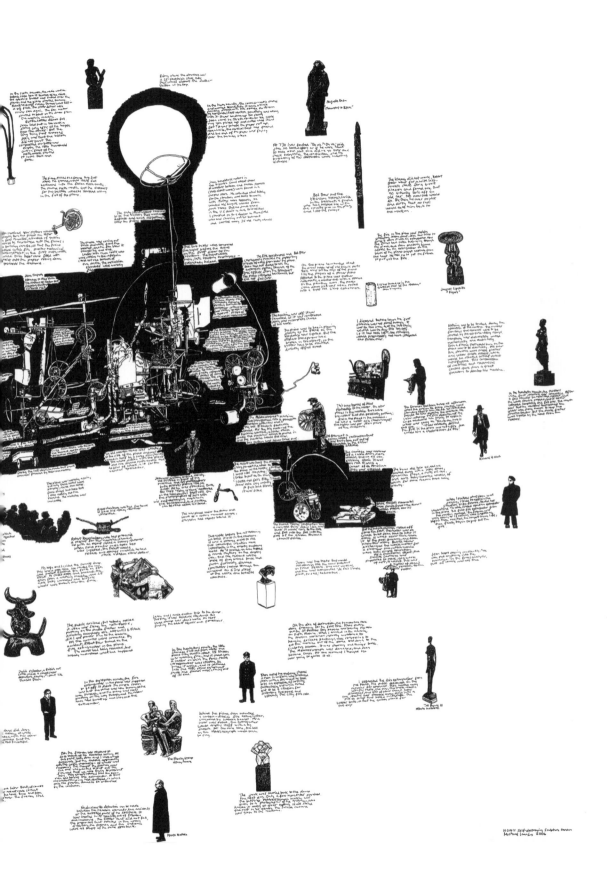

H2NY Suicide in a Garden
2006
Oil stick on paper
122 × 153 cm. / 48 × 60¼ in.

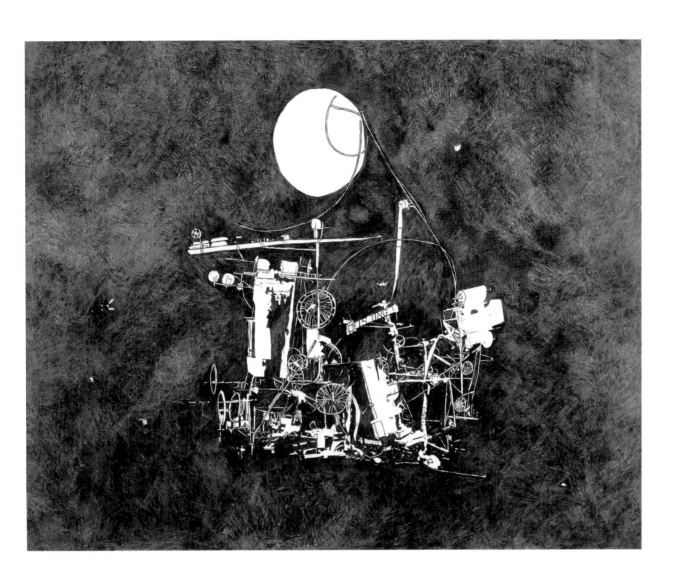

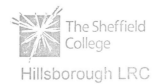

H2NY Self-Destroying Work of Art
2006
Oil stick on paper
122 × 152 cm. / 48 × 59⅞ in.

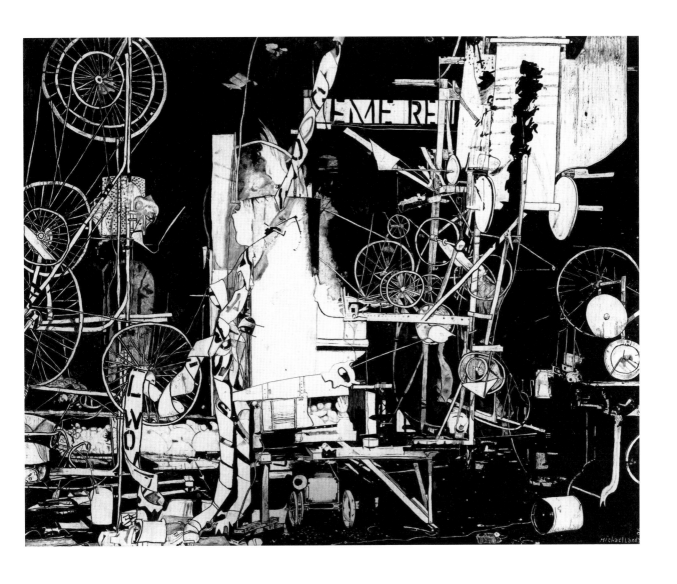

H2NY. Modern Art Goes Boom
2006
Glue and gouache on paper
153 × 123 cm. / 60¼ × 48½ in.

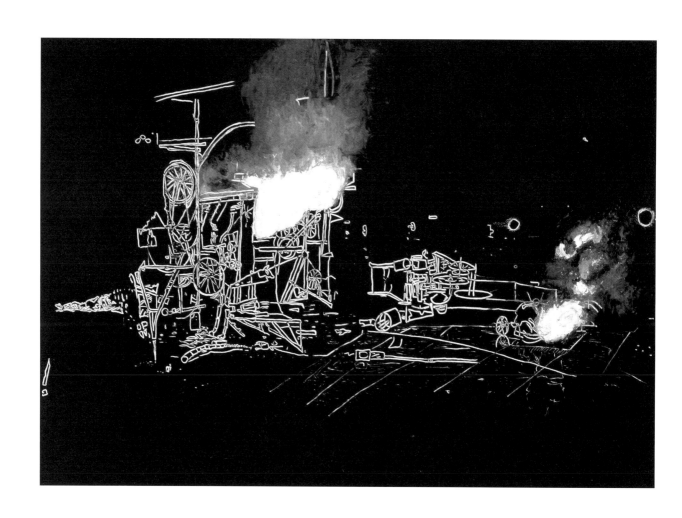

H2NY Machine Comedy
2006
Oil stick on paper
60 × 84 cm. / 23⅝ × 33 in.

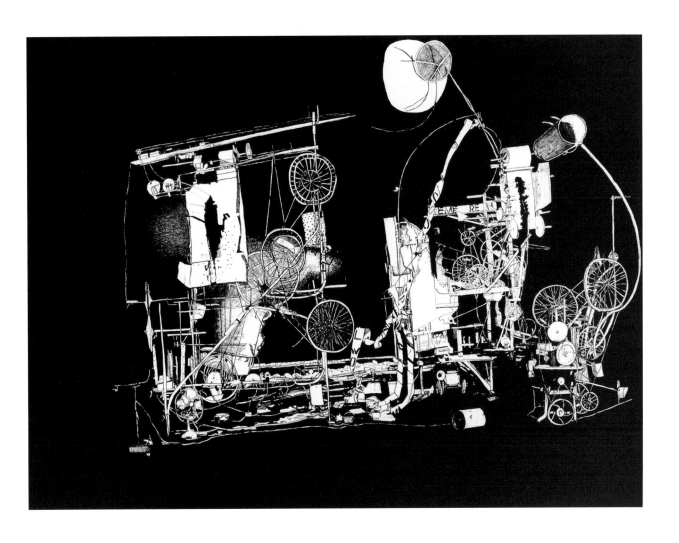

H2NY How to Commit Auto-Destructive Suicide
at the Sculpture Garden
2006
Charcoal on paper
101.5 × 137 cm. / 40 × 54 in.

H2NY Finale with Axes
2006
Glue and gouache on paper
66.5 × 101.5 cm. / 26¼ × 40 in.

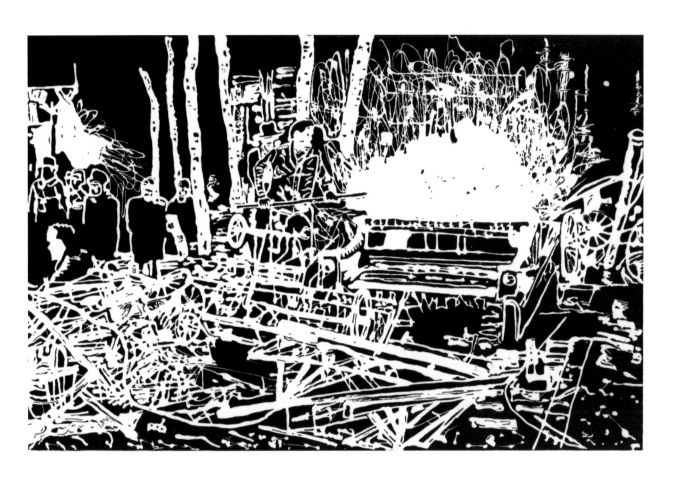

H2NY Gadget to end all Gadgets,
burns out, New York Journal
2006
Oil stick on paper
76 × 57.5 cm. / 30 × 22⅝ in.

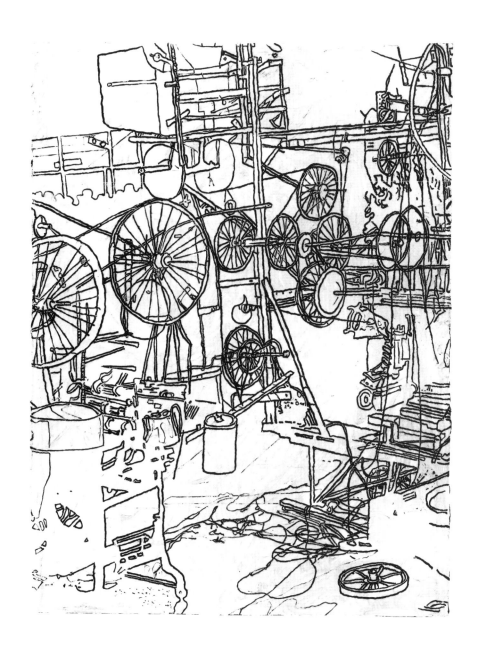

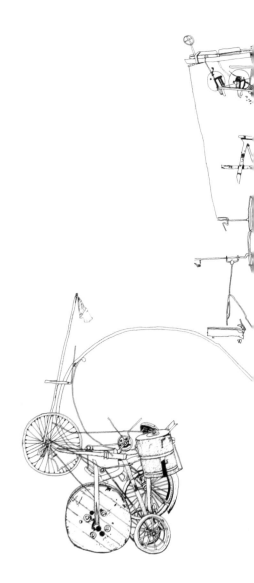

H2NY Suicide Attempt at the Sculpture Garden
2006
Ink on paper
70 × 100 cm. / 27½ × 39¾ in.

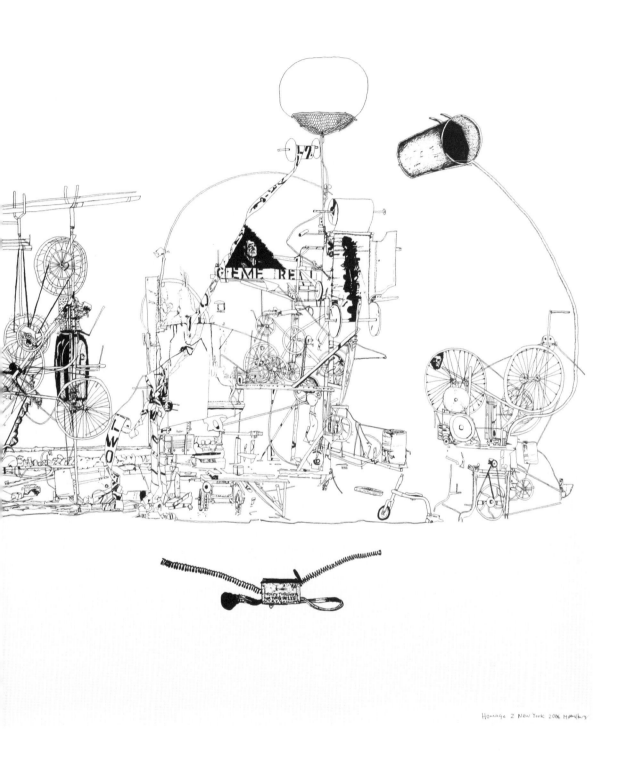

Homage 2 New York 2006 M Hulburg

H 2 N Y Self-Destroying Machine
2006
Oil stick on paper
101.5 × 137 cm. / 40 × 53⅞ in.

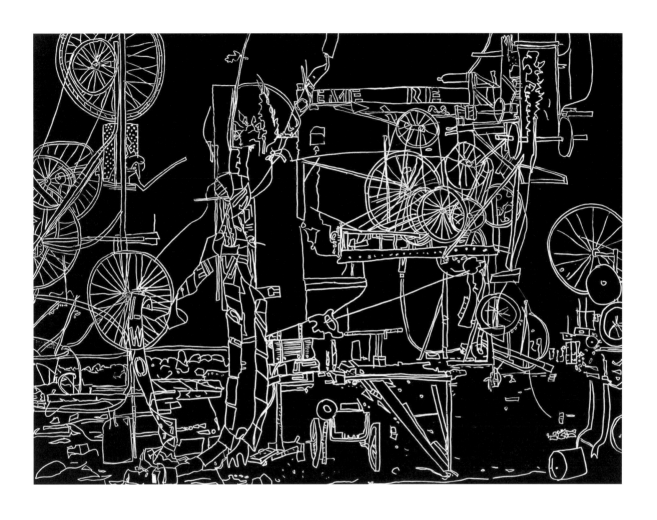

H2NY Machine Tries to Die for its Art, The New York Times
2006
Oil stick on paper
122 × 152.5 cm. / 48 × 60 in.

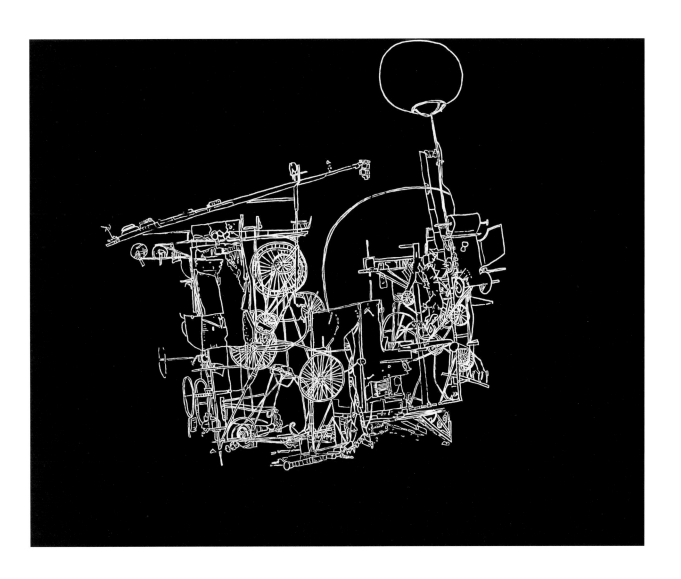

H2NY Machine Left in Ruins
2006
Correction fluid on paper
30 × 42 cm. / 11¾ × 16½ in.

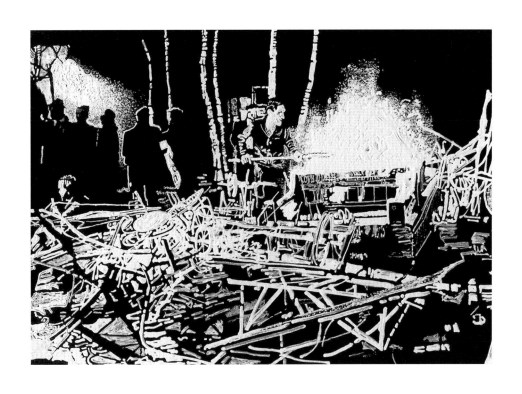

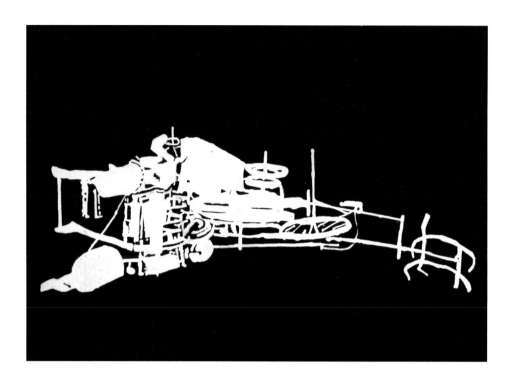

H2NY Addressograph Machine Lays Dying
2006
Correction fluid on paper
30 × 42 cm. / 11¾ × 16½ in.

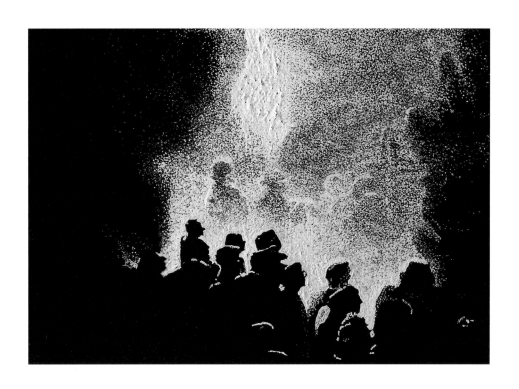

H2NY The Audience Gave a Rousing Cheer
for the Dying Monster
2006
Correction fluid on paper
30 × 42 cm. / 11¾ × 16½ in.

H2NY Apparition at the Sculpture Garden,
17th March 2006
2006
Ink on paper
70 × 100 cm. / 27⁹⁄₁₆ × 39⅜ in.

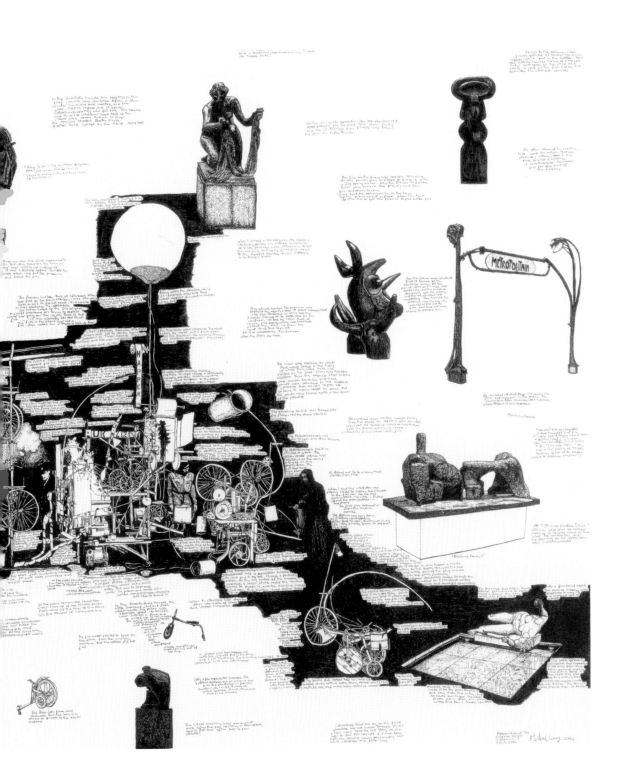

H2NY Suicide Carriage 2
2006
Glue and gouache on paper
40.6 × 30.6 cm. / 16 × 12 in.

H2NY Tinguely Machine Beats Itself Into a Fiery Frenzy
2006
Correction fluid on paper
30 × 42 cm. / 11¾ × 16½ in.

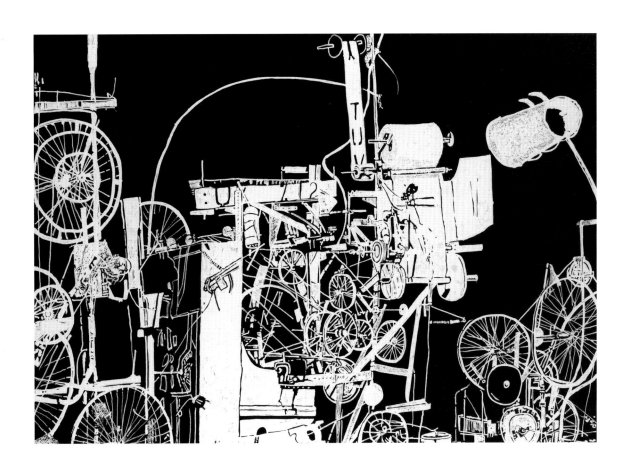

H2NY Three Piano Notes
2006
Correction fluid on paper
59 × 84 cm. / 23¼ × 33¹⁄₁₆ in.

H2NY One Night Stand
2006
Glue and gouache on paper
122 × 152 cm. / 48 × 59 $^{13}/_{16}$ in.

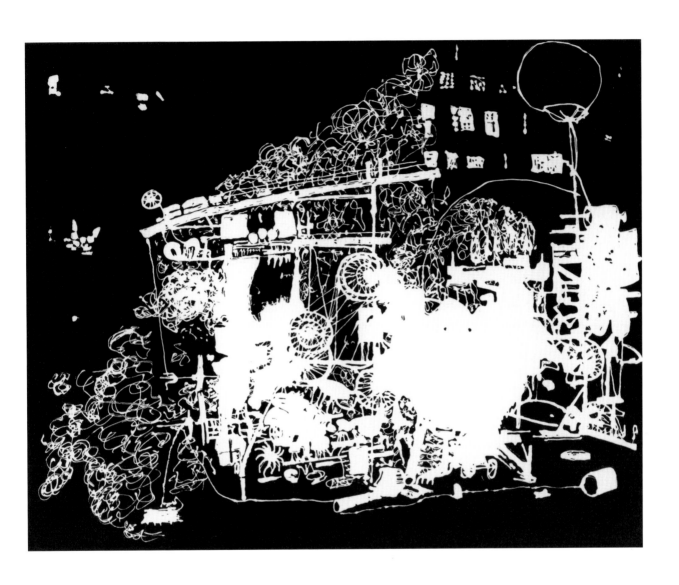

H2NY Metallic Suicide
2006
Glue and gouache on paper
152 × 122 cm. / 59⅞ × 48 in.

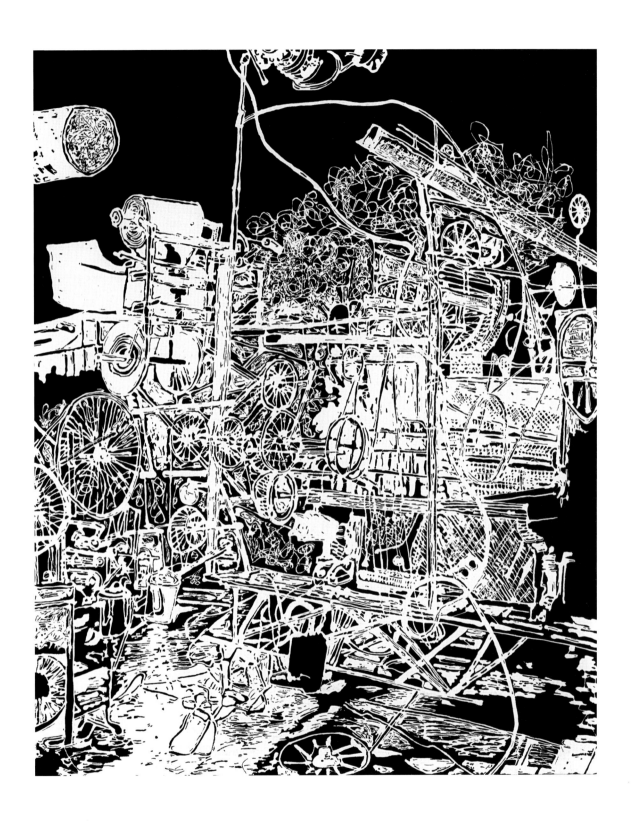

H2NY Machine Committing Suicide
2006
Oil stick on paper
122×152 cm. / $48 \times 59\,{}^{13}\!/_{16}$ in.

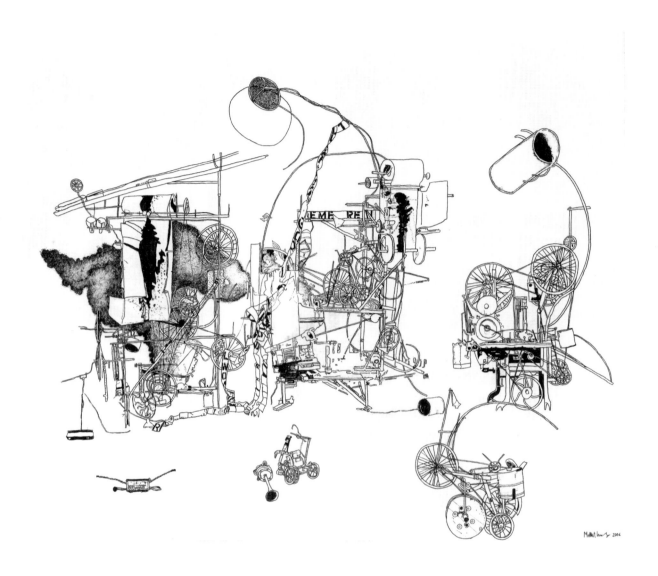

H2NY Choreographed Suicide at the Sculpture Garden
2006
Oil stick on paper
101.5 × 137 cm. / 40 × 54 in.

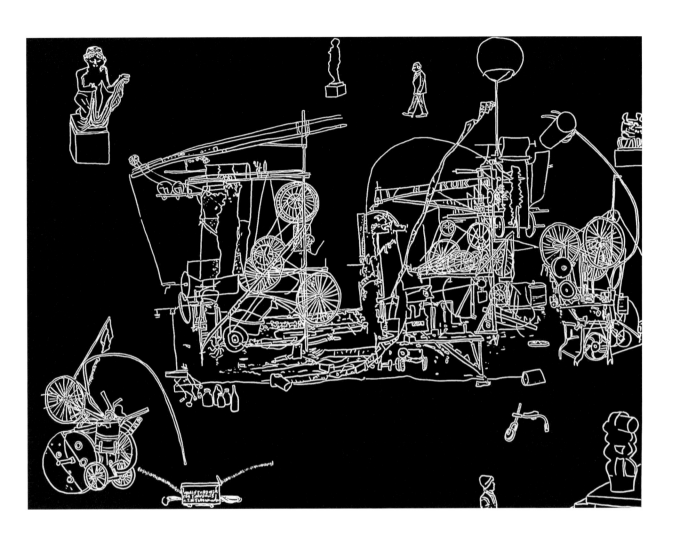

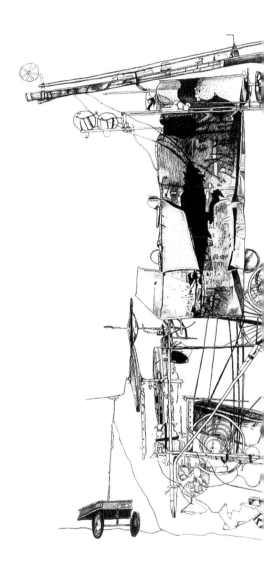

**H2NY Self-Constructing Self-Destroying Tinguely Machine,
Museum of Modern Art, 17 March, 1960**
2006
Charcoal on paper
150 × 227 cm. / 59 × 89⅜ in.

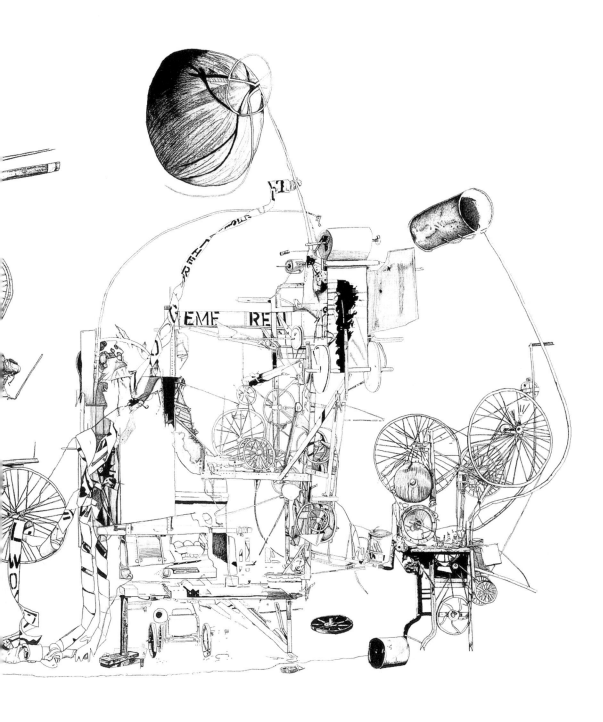

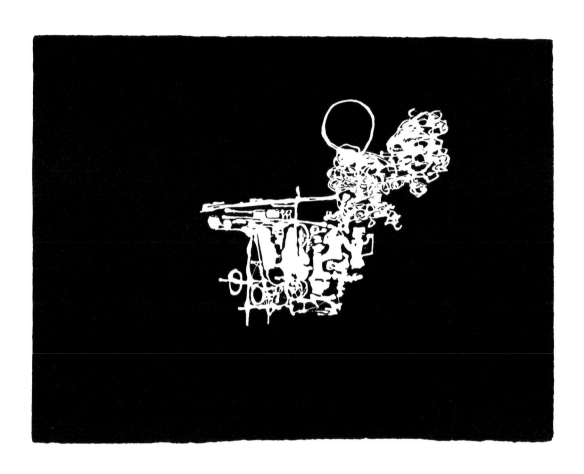

H2NY Kinetic Structure that Destroys Itself
2006
Glue and gouache on paper
57 × 76 cm / 22 ⁷⁄₁₆ × 29 ¹⁵⁄₁₆ in.

Catalogue List

H2NY Picture-Making Machine 2
2006
Oil stick on paper
152 × 122 cm. / 59⅞ × 48 in.
The Lodeveans Collection
Courtesy Thomas Dane Gallery
(page 13)

H2NY Tinguely's Contraption, Nation
2006
Oil stick on paper
101.5 × 67 cm. / 40 × 26½ in.
Courtesy Alexander and Bonin
(page 15)

H2NY Self-Constructing,
Self-Destroying
2006
Oil stick on paper
152.5 × 122 cm. / 60 × 48 in.
Jeremy Lewison Limited
Courtesy Alexander and Bonin
(page 17)

H2NY Self-Destroying Contraption
Breaks Down
2006
Glue and gouache on paper
152 × 122 cm. / 57¾ × 48 in.
Private Collection, London
Courtesy Thomas Dane Gallery
(page 19)

H2NY Choreographed Demise
2006
Glue and gouache on paper
30.6 × 40.6 cm. / 12 × 16 in.
Courtesy Alexander and Bonin
(page 20)

H2NY The Tinguely Machine,
The Village Voice
2006
oil stick on paper
59.2 × 84 cm. / 23¼ × 33 in.
Courtesy Alexander and Bonin
(page 21)

H2NY The Constructive Destruction
of a Destructive Construction
2006
Oil stick on paper
137 × 101.6 cm. / 54 × 40 in.
Courtesy Alexander and Bonin
(page 23)

H2NY Blazing Sculpture 'Watered
Down', The Stars and Stripes
2006
Oil stick on paper
122 × 153 cm. / 48 × 60¼ in.
Courtesy Alexander and Bonin
(page 25)

H2NY Mr. Tinguely Makes Fools
of Machines
2006
Glue and gouache on paper
101.6 × 66.7 cm. / 40 × 26¼ in.
Courtesy Alexander and Bonin
(page 27)

H2NY Kinetic Apparition
2006
Glue and gouache on paper
122 × 152.5 cm. / 48 × 60 in.
Courtesy Alexander and Bonin
(page 28)

H2NY Autodestructive Suicide
at the Garden
2006
Glue and gouache on paper
122 × 152.5 cm. / 48 × 60 in.
Courtesy Alexander and Bonin
(page 29)

H2NY Suicide Carriage Breaks
Down on its Way to Down Itself
in Maillols, The River
2006
Charcoal on paper
220 × 137.5 cm. / 80⅜ × 54¼ in.
The Dakis Joannou Collection, Athens
Courtesy Thomas Dane Gallery
(page 31)

H2NY Burning Piano
2006
Glue and gouache on paper
67.5 × 102.5 cm. / 26½ × 40⅜ in.
Courtesy Alexander and Bonin
(page 32)

H2NY Self-Destructing
Suicide Machine
2006
Charcoal on paper
234 × 150 cm. / 92 × 59 in.
Courtesy Alexander and Bonin
(page 33)

H2NY Self-Constructing,
Self-Destroying Machine
2006
Charcoal on paper
150 × 218.5 cm. / 59 × 86 in.
Courtesy Alexander and Bonin
(pages 34/35)

H2NY Self-Destroying
Scupture Garden
2006
Ink on paper
70 × 81 cm. / 27½ × 31⅞ in.
Private Collection
Courtesy Thomas Dane Gallery
(pages 36/37)

H2NY Suicide in a Garden
2006
Oil stick on paper
122 × 153 cm. / 48 × 60¼ in.
Courtesy Alexander and Bonin
(page 39)

H2NY Self-Destroying Work of Art
2006
Oil stick on paper
122 × 152 cm. / 48 × 59⅞ in.
Collection John Kaldor
Courtesy Thomas Dane Gallery
(page 41)

H2NY Modern Art Goes Boom
2006
Glue and gouache on paper
153 × 123 cm. / 60¼ × 48½ in.
Courtesy Alexander and Bonin
(page 43)

H2NY Machine Comedy
2006
Oil stick on paper
60 × 84 cm. / 23⅝ × 33 in.
Courtesy Alexander and Bonin
(page 44)

H2NY How to Commit
Auto-Destructive Suicide
at the Sculpture Garden
2006
Charcoal on paper
101.5 × 137 cm. / 40 × 54 in.
Gordon Watson Limited
Courtesy Thomas Dane Gallery
(page 45)

H2NY Finale with Axes
2006
Glue and gouache on paper
66.5 × 101.5 cm. / 26¼ × 40 in.
Colection David Roberts, London
Courtesy Alexander and Bonin
(page 47)

**H2NY Gadget to end all Gadgets,
burns out, New York Journal**
2006
Oil stick on paper
76 × 57.5 cm. / 30 × 22⅝ in.
Courtesy Alexander and Bonin
(page 49)

**H2NY Suicide Attempt at
the Sculpture Garden**
2006
Ink on paper
70 × 100 cm. / 27½ × 39¾ in.
Collection de Bruin-Heijn, Wassenaar
Courtesy Alexander and Bonin
(pages 50/51)

H2NY Self-Destroying Machine
2006
Oil stick on paper
101.5 × 137 cm. / 40 × 53⅞ in.
Collection Naomi Milgrom
Courtesy Thomas Dane Gallery
(page 53)

**H2NY Machine Tries to Die
for its Art, The New York Times**
2006
Oil stick on paper
122 × 152.5 cm. / 48 × 60 in.
Courtesy Alexander and Bonin
(page 55)

H2NY Machine Left in Ruins
2006
Correction fluid on paper
30 × 42 cm. / 11¾ × 16½ in.
Courtesy Thomas Dane Gallery
(page 57)

**H2NY Addressograph Machine
Lays Dying**
2006
Correction fluid on paper
30 × 42 cm. / 11¾ × 16½ in.
Courtesy Thomas Dane Gallery
(page 58)

**H2NY The Audience Gave a Rousing
Cheer for the Dying Monster**
2006
Correction fluid on paper
30 × 42 cm. / 11¾ × 16½ in.
Courtesy Thomas Dane Gallery
(page 59)

**H2NY Apparition at the Sculpture
Garden, 17th March 2006**
2006
Ink on paper
70 × 100 cm. / 27⁹⁄₁₆ × 39⅜ in.
Collection Andrew Kaldor
Courtesy Thomas Dane Gallery
(pages 60/61)

H2NY Suicide Carriage 2
2006
Glue and gouache on paper
40.6 × 30.6 cm. / 16 × 12 in.
Private Collection
Courtesy Thomas Dane Gallery
(page 63)

**H2NY Tinguely Machine Beats
Itself Into a Fiery Frenzy**
2006
Correction fluid on paper
30 × 42 cm. / 11¾ × 16½ in.
Courtesy Thomas Dane Gallery
(page 64)

H2NY Three Piano Notes
2006
Correction fluid on paper
59 × 84 cm. / 23¼ × 33⅛ in.
Arts Council Collection, Hayward Gallery,
London
Courtesy Thomas Dane Gallery
(page 65)

H2NY One Night Stand
2006
Glue and gouache on paper
122 × 152 cm. / 48 × 59¹³⁄₁₆ in.
Jeremy Lewison Limited
Courtesy Thomas Dane Gallery
(page 67)

H2NY Metallic Suicide
2006
Glue and gouache on paper
152 × 122 cm. / 59⅞ × 48 in.
The Lodeveans Collection
Courtesy Thomas Dane Gallery
(page 69)

H2NY Machine Committing Suicide
2006
Oil stick on paper
122 × 152 cm. / 48 × 59¹³⁄₁₆ in.
Collection Thomas Dane, London
Courtesy Thomas Dane Gallery
(page 71)

**H2NY Choreographed Suicide
at the Sculpture Garden**
2006
Oil stick on paper
101.5 × 137 cm. / 40 × 54 in.
Private Collection, London
Courtesy Thomas Dane Gallery
(page 73)

**H2NY Self-Constructing Self-
Destroying Tinguely Machine, Museum
of Modern Art, 17 March, 1960**
2006
Charcoal on paper
150 × 227 cm. / 59 × 89⅜ in.
Tate
Courtesy Thomas Dane Gallery
(pages 74/75)

**H2NY Kinetic Structure
that Destroys Itself**
2006
Glue and gouache on paper
57 × 76 cm / 22⁷⁄₁₆ × 29¹⁵⁄₁₆ in.
Private Collection
Courtesy Thomas Dane Gallery
(page 76)

Michael Landy Selected Biography

Born in London, 1963
Lives and works in London

Goldsmith's College, London, 1985–88

Solo Exhibitions

2007

Michael Landy H2NY,
Alexander and Bonin, New York

2004

*Michael Landy: WELCOME TO MY
WORLD BUILT WITH YOU IN MIND*,
Thomas Dane, London

Michael Landy: Semi-detached, Tate
Britain, London

2003

Michael Landy: Nourishment,
Sabine Knust/Maximilianverlag, Munich

2002

Michael Landy: Nourishment,
Maureen Paley/Interim Art, London

2001

Michael Landy: Break Down, C&A Store,
Marble Arch, London

2000

Handjobs (with Gillian Wearing),
Approach Gallery, London

1999

Michael Landy at Home, 7 Fashion Street,
London

1996

Scrapheap Services, Chisenhale Gallery,
London

1995

*Multiples: Editions from Scrapheap
Services*, Ridinghouse Editions, London

Scrapheap Services, Tate Gallery, London

1993

Michael Landy: Warning Signs,
Karsten Schubert, London

1992

Closing Down Sale, Karsten Schubert,
London

1991

Michael Landy: Appropriations 1–4,
Karsten Schubert, London

1990

Market, Building One, London

Galerie Tanja Grunert, Cologne

Studio Marconi, Milan

1989

Karsten Schubert, London

Sovereign, Projects for the windows of
the Grey Art Gallery and Study Center,
New York University.

Selcted Group Exhbitions

2004

Bad Behaviour, an Arts Council Collection
exhibition touring from the Hayward
Gallery, London

2003

L'Air du Temps, Bloomberg Space, London

Shopping: Art and Consumer Culture,
Kunstverein Frankfurt and Tate Liverpool

Micro/Macro: British Art 1996–2002,
Mucsarnok Kunsthalle, Budapest

*For the Record: Drawing Contemporary
Life*, Vancouver Art Gallery

2002/3

*From Blast To Frieze: A Century of
British Art*, Kunstmuseum Wolfsburg and
Les Abattoirs, Toulouse

2002

Face/Off, Kettle's Yard, Cambridge

XXIV Bienal de São Paulo

2001

*Out of line: Drawings from the Arts
Council Collection*, Hayward Gallery:
York City Art Gallery, York and tour

La Otra Britania, Centro Cultural Tecla
Sala, Barcelona

2000

British Art Show 5, Edinburgh; Cardiff;
Birmingham

Diary, Cornerhouse Gallery, Manchester
Puerile 69, Living Art Museum, Reykjavik

1999

*Sensation: Young British artists from
The Saatchi Collection*, Brooklyn
Museum, New York

Waste Management, Art Gallery of
Ontario, Toronto

Trace and *Art Lovers*, The Liverpool
Biennal of Contemporary Art

1998

*Sensation: Young British artists from
The Saatchi Collection*, Hamburger
Bahnhof-Museum für Gegenwart, Berlin

1997

*Sensation: Young British Artists from
the Saatchi Collection*, Royal Academy
of Arts London

*Material Culture: The Object in British
Art of the 1980s and 90s'*, Hayward
Gallery, London

1996

Arts Council Collection New Purchases,
Arts Council; Hatton Gallery, Newcastle
upon Tyne; Harris Museum and Art Gallery,
Preston; Oldham Art Gallery, Sheffield;
Angel Row Gallery, Nottingham; Ormeau
Baths Gallery, Belfast; Arnolfini Gallery,
Bristol

Plastic, Walsall Museum and Art Gallery;
Arnolfini Gallery, Bristol

*From Figure to Object: A Century of
Sculptors' Drawings*, Frith Street Gallery
and Karsten Schubert, London

1995

Brilliant: New Art from Britain, Walker Art Center, Minneapolis; Contemporary Arts Museum, Houston

12th International Biennial of Small Sculpture, Murska Sobota, Slovenia

Here and Now, Serpentine Gallery, London

Contemporary British Art in Print, Scottish National Gallery of Modern Art, Edinburgh; Yale Center for British Art, New Haven, CT

1994

Not Self-Portrait: Larry Clark, Angus Fairhurst, Gilbert and George, Gary Hume, Michael Landy, Abigail Lane, Sarah Lucas, Marc Quinn, Cindy Sherman, Mark Wallinger, Gillian Wearing, Karsten Schubert, London

1993

You've Seen the Rest Now Try the Best: Keith Coventry, Michael Landy, Mark Wallinger, City Racing Gallery, London
Five Works: Keith Conventry, Michael Landy, Bridget Riley, Rachel Whiteread and Alison Wilding, Karsten Schubert, London

Visione Britannica, Valentina Moncada and Pino Casagrande, Rome

1992

Instructions Received by Liam Gillick: Angela Bulloch, Adam Chodzko, Matthew Collings, Jeremy Deller, Douglas Gordon, Gary Hume, Michael Landy, Jonathon Monk, Simon Patterson, Brendan Quick, Phillip Riley, Caroline Russel, Giorgio Sadoti, Gavin Turk, Gillian Wearing, Galleria Gio Marconi, Milan

1991

Confrontaciones, Palacio de Velasquez, Madrid

We've Lost ET but the Boy's Coming Back: Peter Cain, Michael Jenkins and Michael Landy, Karsten Schubert, London

Centenary Exhibition: Michael Craig-Martin, Michael Landy and Julian Opie, Goldsmiths' Gallery, London

Broken English: Angela Bulloch, Ian Davenport, Anya Gallaccio, Damien Hirst, Gary Hume, Michael Landy, Sarah Staton and Rachel Whiteread, Serpentine Gallery, London

Michael Landy, Chrsitian Marclay, Peter Nagy, Andreas Schon and Steve Wolfe, Jay Gorney Modern Art, New York

Unknown Europe, Miedzyhardow e Stowarzysznenie Krytykow Sztuki, Krakow, Poland

1990

East Country Yard Show, London

1989

Young British Art Show: Angela Bulloch, Michael Landy, Gary Hume, Esther Schipper, Cologne

Home Truths, Catello di Rivoli, Turin

La Biennal de Barcelona, Spain

Dan Flavin, Michael Landy, Thomas Locher, Karsten Schubert, London

1988

That Which Appears is Good, That Which is Good Appears, Galerie Tanja Grunert, Cologne

Ian Davenport, Gary Hume & Michael Landy, Karsten Schubert, London
Freeze, London

The New York Times

Machine Tries to Die for Its Art

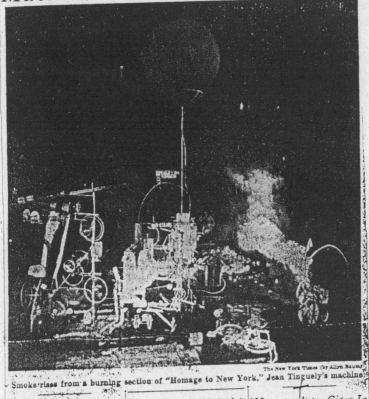

Smoke rises from a burning section of "Homage to New York," Jean Tinguely's machine.

Device Saws, Melts and Beats Itself at Museum

By JOHN CANADAY

Eighty bicycle, tricycle and wagon wheels, a piano of sorts, some metal drums, an addressing machine, a child's cart, an enameled bathtub, a meteorological trial balloon, a bunch of bottles, and a certain amount of material picked up in city dumps in New Jersey, all painted white, were scheduled to commit mutual murder and suicide by sawing, hammering and melting one another in the garden of the Museum of Modern Art last evening.

They came close to doing so, and may in fact be written off as a dead loss, the rescue squad having arrived a bit too late to save them. But the rescue squad was still a lot too early from the point of view of some 250 invited spectators who had waited an hour and a half with their feet in cold slush to witness the promised spectacle.

The machine composed of the listed objects and many others was powered by fifteen motors to be a "self-destroying work of art conceived and built for this occasion" by Jean Tinguely, a Swiss.

Called "Homage to New York," a title that gives one to think, the machine was an object of bizarre attraction if not of classical beauty. Before it began making trouble for itself it measured 23 feet long by 27 feet high.

From the beginning the process of destruction failed to go according to schedule. A roll of paper that was supposed to move under the caresses of some large paint brushes and

get painted, moved instead in the opposite direction and escaped.

A large section of the machine fell over on its side before it was supposed to do so, and although Mr. Tinguely managed to make one section of it walk away under its own power for a few feet, he had the rest of his trouble of construction for nothing.

Also he had to goad his monster from time to time, apparently when relay systems failed to function.

Things weren't going too badly, however, until a watchful fireman decided things were out of control and applied an extinguisher. (An automatic one had been built into the piano, which was in flames as planned, but failed to function.) The spectacle ended with boos for the fireman and loyal bravos for Mr. Tinguely.

However, the significance of the event lies not in the fact that it was, over-all, a fiasco, but in the intention of Mr. Tinguely and the Museum of Modern Art in staging it in the first place.

In conceiving and carrying out (as far as he was able) what must seem to most people only a preposterous and wasteful stunt, Mr. Tinguely was, rather, a kind of philosopher, even if one of nihilism, and the leading one of a current generation of artists descended from the dadaists of World War I times.

Dada, which was an art dedicated to the cultivation of nonsense as a manifestation of despair, seemed to have burned itself out as an intellectual escape during the Twenties. Its recent revival, in force, is without much question a reflection of a similar despair in our own moment.

Described as "an ironic, witty

'Homage' to City Is Extinguished as Crowd Boos

and thoughtful comment on contemporary life and art," the self-destroying machine is—or rather was—exactly that, a legitimate work of art as social expression, even if it pooped a bit.

Mr. Tinguely makes fools of machines, while the rest of mankind supinely permits machines to make fools of them.

A little irony over and above the intended irony, however, is that Mr. Tinguely's machine wasn't quite good enough, as a machine, to make his point, even before it fell afoul of the city's fire code.

ODD KIND OF ART

Thoughts on Destruction and Creation After a Suicide in a Garden

By JOHN CANADAY

JEAN Tinguely's machine called "Homage to New York," characterized as "a self-destroying work of art," which limped to its demise Thursday a week ago before a selected audience in the garden of the Museum of Modern Art, was a bizarre contraption indeed, born of Despair out of Impertinence, if I understand its genealogy. It reflected, as a work of art must do willy-nilly, an aspect of its time, but did so by plan.

As reported in this paper the morning after, "Homage to New York" was a multiple super-gadget constructed of such elements as old bicycle wheels, an already moribund piano, a battered toy wagon, a meteorological trial balloon, bottles, and other material picked up in junk yards. Powered by fifteen motors, it was capable, or would have been if it had been better constructed, of producing abstract paintings in caricature of the "action" school, erasing them, making music of a sort, setting fire to itself, and even of procreating in the form of a segment that, detaching itself from the parent machine, had the power of independent locomotion.

After some emergency midwifery performed by Mr. Tinguely, this little monster actually did hobble away for a few paces, with a gait altogether grotesque, hilarious, and eerie. Finally, after more human intervention than a good machine bent on suicide should require, the end was obviously near and the coup de grâce was administered by a fireman with an extinguisher.

Implications

Some of the implications of the self-destroying machine as in 1909, advocated tearing down all institutions devoted to the preservation of the past, such as museums, libraries, and schools, a suggestion that failed to catch on. A more significant kind of destruction, however, was already taking place in cubism, not as a program of destruction as a policy, but incidentally in the course of experiments branching out in one direction from the art of Cézanne.

This was the destruction of the pictorial image as art had always known it in one form or another—"form" in a double sense here — by shattering it into multitudinous planes, planes that, in effect, have never been reassembled in their pre-cubist relationship. No painter who has passed through the experience of cubism, even vicariously as is the case with young painters today, can ever again see a solid object as pre-cubist painters saw it.

Mondrian on Destruction

But this was not the end. "I think," wrote Mondrian in the margin of a letter to James Johnson Sweeney in 1943, "the destructive element is too much neglected in art." Mondrian objected to cubism as an art that intended to express volume, even in a new way, since this was opposed to his contention that volume had to be destroyed. The way to destroy volume is to paint in a single plane, which Mondrian did in compositions of flat rectangles defined by precise horizontal and vertical lines. Mondrian next set out, he said, to destroy the lines defining the rectangles by creating mutual oppositions between them.

This process must seem one of progressively diminishing re- them: surfaces that are moldy, broken, corroded, ragged, dripping, brush strokes executed with the sloppy brutality of cornered men, of artists who are displaced persons who tour the inner ruins much as, in the last century, the Romantics toured the ruins of the outside world, who have made a central principle of the unformed, the irrational, and the uncontrolled, and have created an "image" that is reduced to the elementary experience of the kinesthetic pleasure of the act of painting.

Most Destructive Art

Mr. Kepes is not commenting on abstract art, but on one aspect of contemporary art that happens to be abstract. He does

clude, in the field of social comment, the gesture of independence against machines in a world they are beginning to control. And as an essay in criticism, taking as its subject the transient and inchoate nature of much contemporary art, the machine made its point trenchantly, even if somewhat unfairly by means of reduction to absurdity.

But without tracing these ideas further, just now, we might give a thought to the persistence of destruction as a factor in the ideology of the artist in the twentieth century. Certainly this is peculiar to him in contrast with artists of other centuries, for only by the most precious forcing can we pretend that until our time art was anything but unquestioningly dedicated to the general ideal of capturing, holding and ordering the life and thought of man.

Our preoccupation with destruction has a positive facet of sorts in the effort of the twentieth-century artist to clear his decks of a past that has piled up for so long that he feels stifled under it. The futurists, the art historian, who sees behind each Mondrian, so to speak, the whole story of which the spare and ultra-refined painting is the end result. But this kind of destruction, as Mondrian called it, or purification or distillation as it could be called, was destruction toward a goal, and above all an exercise in logic.

Anti-Logic

Destruction of another kind, the destruction of logic or at least its avoidance, is represented by painters who could say with Nicolas de Staël, "I believe in the accidental. As soon as I sense a logic, too much logic, I become unnerved, and naturally tend towards the illogical." And in an article of interest to any painter, the introduction to the Winter, 1960, issue of "Daedalus," the journal of the American Academy of Arts and Sciences, Gyorgy Kepes writes of the artist who is most destructive of all, the contemporary painter or sculptor who speaks in "idioms in tune with the twilight spirit that created of abstract expressionism and "action painting," which except in their most glowing moments are not only the most destructive art of all, but also the most vicious, because the destructive principle is mistaken for a constructive one by the artists.

It is at this point that Mr. Tinguely's art begins to make sense. The reason I was impressed by his foolish and ill-constructed machine was that it had a perverse honesty. Like the dadaists before him, and he really does not do much more than elaborate upon them, he is not really inventive, but only ingenious—Mr. Tinguely admits that mankind is licked.

Nature of Dada

Dada was a cult of unreason, an escape into nihilism, but a frank, even a declared one. Witnessing World War I—and how much more we have witnessed since then!—the dadaists seemed to say that if millennia of efforts to apply reason and logic could bring men to no better pass, then reason and logic

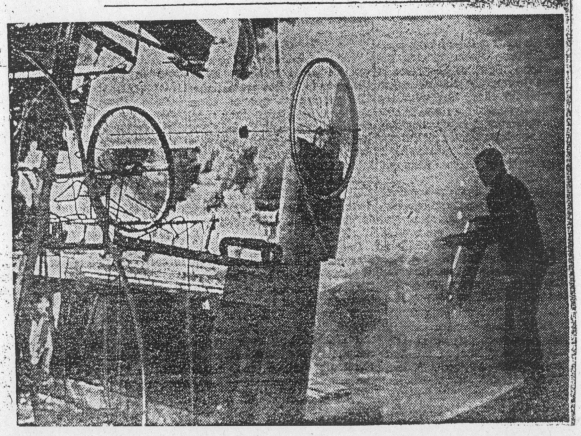

Extract from Calvin Tomkins,
'Jean Tinguely – Beyond the Machine',
The New Yorker, February 10, 1962.

George Staempfli, a New York gallery owner and art dealer, had met Tinguely in Paris and promised him a New York show, and in January, 1960, Tinguely crossed the Atlantic in tourist class on the Queen Elizabeth to be on hand for the first exposure of his art in America. During the trip, he began drawing up rough sketches for a work that would express some of his complex ideas about New York, a city he had never seen. New York, to Tinguely, had always seemed the place where modern man was in closest contact with his machines. "The skyscraper itself is a kind of machine," he has said. "The American house is a machine. I saw in my mind's eye all those skyscrapers, those monster buildings, all that magnificent accumulation of human power and vitality, all that uneasiness, as though everyone were living on the edge of a precipice, and I though how nice it would be to make a little machine there that would be conceived, like Chinese fireworks, in total anarchy and freedom." The machine that Tinguely envisioned was to be called "Homage to New York," and its sole raison d'être would be to destroy itself in one act of glorious mechanical freedom. The simplicity, appropriateness and grandeur of this vision so impressed Tinguely that he decided at once that the only proper locale for the event was the outdoor sculpture garden at the Museum of Modern Art, and as soon as he landed he set about achieving this almost impossible objective. The fact that he spoke practically no English and that he had few friends and, at best, a tiny reputation in New York seemed small obstacles to him, and he immediately began lining up supporters for his plan. Dore Ashton, an art critic for the Times who had seen his work in Europe, came down to the pier to meet him, and he showed her the drawings for his machine. "It has to be in the Museum of Modern Art," she remembers him saying. "It has to end up in the garbage cans of the museum." Miss Ashton, who had considerable opportunity to observe Tinguely in action during the next few weeks, was somewhat awed by his talent for getting what he wanted. "He often adopts the manner of a simple peasant when you ask him serious questions," she reports, "but he is certainly not at all simple. He is a very complicated person. If he feels you understand him, you're in; if you don't, he uses you."

One of the people who proved most helpful to Tinguely was Dr. Richard Huelsenbeck, in whose apartment he stayed for the three months he was in New York. Huelsenbeck, a psychiatrist, had been in his younger days a poet and a member of the group that founded the original Dada movement, in a Zurich café in 1917. He had met Tinguely in Paris, admired his work and enthusiastically proclaimed him a "Meta-Dadaist," who had "fulfilled certain ideas of ours, notably the idea of motion." Dr. Huelsenbeck provided Tinguely's entrée to the neo-Dada group in New York, made up of Robert Rauschenberg, Jasper Johns, John Chamberlain, and others, and helped him renew his acquaintance with Marcel Duchamp, still one of the most influential of contemporary artists, although for the last thirty years, living quietly in New York, he has refrained from artistic production. Duchamp and Tinguely had met before, in Paris, and were full of admiration for one another. "I feel with him a closeness and a rapport that I have felt with few other artists," Duchamp has said. "He has this great thing, a sense of humour—something I have been preaching for artists all my life. Painters usually think they are the last word in divinity; they become like *grands prêtres*. I believe in humor as a thing of great dignity, and so does Tinguely."

The neo-Dada group told Tinguely that the best he could hope for was to place his self-destroying machine in some rented assembly hall in Manhattan, or perhaps in an empty lot. Tinguely, however, would not abandon his dream. George Staempfli had called a staff member of the Museum of Modern Art, and mentioned Tinguely's scheme, and three days later got word that it would not be possible. Undaunted, Tinguely got Dore Ashton to broach the matter to Peter Selz, the museum's young and energetic Curator of Painting and Sculpture Exhibitions. Selz was interested. He had been fascinated by Tinguely's big meta-matic at the Paris Biennale the year before, and he was receptive to the playful and humorous aspects of Tinguely's work. ("Art hasn't been fun for a long time," he said.) Selz spoke to the museum's director, Rene d'Harnoncourt, and this led to a meeting between d'Harnoncourt and Tinguely. D'Harnoncourt asked some searching questions about he machine and received what Tinguely refers to as "spiritual explanations". This was followed by a much longer session between Tinguely and Richard Koch, the museum's Director of Administration. As Tinguely remembers it,

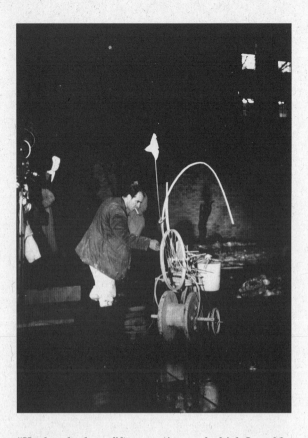

"Koch asked me fifty questions, of which I could answer one or two." Would there be dynamite? Tinguely wasn't sure. Fire? Tinguely didn't know. How long would it last? Tinguely had no idea. Not surprisingly, Koch wouldn't commit himself. Selz, however, kept exerting pressure from his end, and Tinguely's admirers and allies in the neo-Dada group, some of whom had had their own work shown by the museum, mounted a modest crusade on his behalf.

Tinguely's how of meta-matics and rotating reliefs opened in January at the Staempfli Gallery, to astonished but generally friendly reviews. Feature stories on Tinguely appeared in several national magazines. Shortly afterward, the museum reversed its earlier decision, and Tinguely's success was absolute. D'Harnoncourt agreed to let Tinguely set off his doomsday machine in the sculpture garden on the night of March 17th, three weeks off, and offered him the use of the Buckminster Fuller geodesic dome, at the far end of the garden, as a workshop; he assured Tinguely that non one would interfere in any way with the great work—a pledge that was faithfully observed.

Tinguely plunged immediately into a wined-ranging search for material. He bought dozens of used motors and a powerful electric fan in second-hand electrical shops on Canal Street. In an Army-surplus store he found a big orange meteorological balloon and some smoke signals. His friends collected enough money for him to buy a quantity of steel tubing, his only major item of expense, and the museum provided him with his indispensable tool, an acetylene torch. All this, however, was only a beginning. Tinguely likes to surround himself with a great mass of material, from which he draws his ideas, and at that moment he felt overpoweringly in need of bicycle wheels—items that no junk dealer in New York City seemed to have in stock. This problem was solved by Billy Klüver, a young Swedish research scientist whom Tinguely had known in Paris and who was currently working at the Bell laboratories in New Jersey. Klüver now took time off from his work with electron beams and microwave tubes to become Tinguely's assistant, and the first thing he did was to find a bicycle dealer near his home, in Plainfield, New Jersey, who had recently dredged up thirty-five old bicycle wheels from a corner of his lot. "I put them in the back of my car and drove in to the museum about ten o'clock that night," Klüver said later. When Jean saw them, he was like a child; he had expected maybe five or six. His ideas took shape from them. That's how he works. He creates with what comes to hand, and the material shapes the creation. 'I want more wheels,' he said."

The next day, Klüver and his wife raided a dump in Summit, and loaded up their car with twenty-five more bicycle and baby-carriage wheels, a child's bassinet, and the drum from a derelict washing machine. They passed these over the garden wall to Tinguely, who carried them into the Fuller dome and immediately set to work. Two days later, he had finished welding together the first section of his creation. This part centred on a large meta-matic painting machine, and included the basinet and the washing-machine drum as percussion elements. A horizontal roll of paper was to be fed down a sheet-metal trough, where it would be attacked by two large brushes held by an elaborately constructed painting arm. When the paper reached the bottom of the meta-matic, it would be blown out toward the audience by the electric fan.

Material was running short again. This time, Klüver took Tinguely to a big Newark dump. "I had said that his great machine should be one continu-

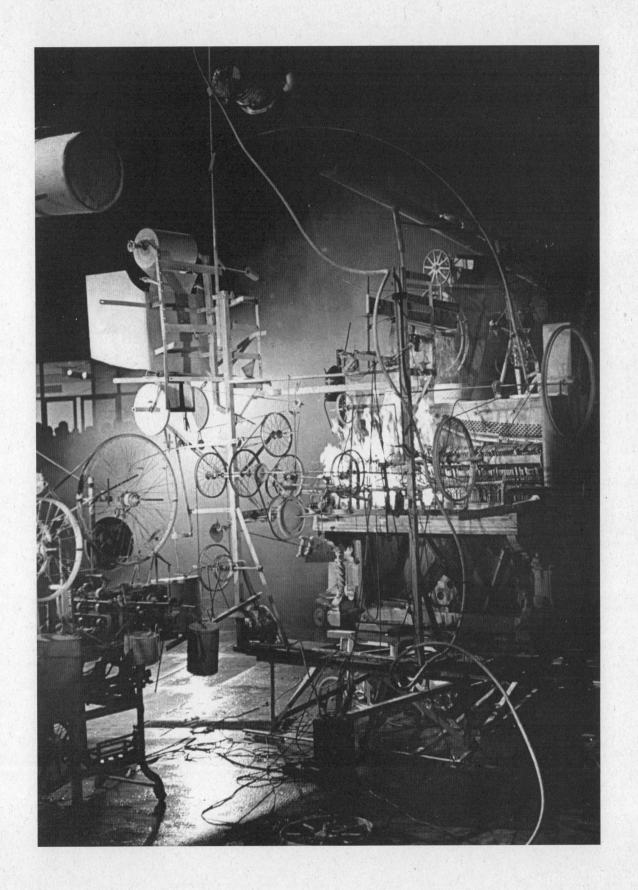

ous process—out of the chaos of the dump and back again," Klüver recalls. "Jean like that, and when he came out and saw the dump he fell in love with the place. He wanted to live there. He had the idea that if he could just find the right girl, they could live right in the dump, like the bums there did, in a little shack, and he could spend his time building large, involved constructions and that eventually the bums would become his friends and help him, although the word 'art' was never mentioned and his constructions would never anything but part of the dump." The local inhabitants of the dump did help Tinguely and Klüver find the materials they wanted, including a cable drum, a rusty oilcan, a bedraggled American flag, and a great many more baby-carriage wheels, of which there seemed to be unlimited quantities. The next day, Klüver located a dealer who was willing to sell him a workable radio and an antique upright piano for ten dollars. Then Tinguely got the museum to sell him, for two dollars, an ancient Addressograph machine that made an incredible amount of noise.

For the next two weeks, Tinguely worked from twelve to sixteen hours a day in the dome, which was damp and ice-cold. The second section of the machine took shape around the piano. Tinguely fashioned ten armatures out of old bicycle parts and mounted them in such a way that they struck the piano keys in sequence, with considerable force. A small meta-matic was attached fro the piano, where it would produce a continuous painting that would immediately roll itself up again—*l'art éphérèmere*. Two pairs of spindles operating at right angles to each other (one vertical, one horizontal) were designed to unroll two texts and roll them up again. The radio, sawed in half but still able to function, was nailed to the piano. The Addressograph machine, with the addition of armatures and a bell, became a percussion instrument. Dozens of wheels were fitted in place to drive the various moving parts. Above the whole structure rose a twenty-foot steel tube supporting the meteorological balloon.

The idea of the machine's destruction had by now begun to seem of only secondary importance to Tinguely. Originally, he had planned to incorporate into the structure a number of saws that would attach the metal supports and cause an ear-splitting din. But an associate of Culver's at Bell laboratories hit on the idea of sawing through the metal tubing in crucial places beforehand, and holding it together with joints of soft metal that would melt when an

electrical charge was sent through concealed wire resistors inside them. Tinguely enthusiastically embrace this new plan. The joints were never really perfected, according to Klüver, but Tinguely no longer cared. "He wasn't interested in perfecting something so that it would be sure to work," Klüver says. "He preferred to spend the time adding new things, new gadgets."

A good many of Tinguely's friends dropped in to lend a hand at odd times and nearly every one of them caught a heavy cold after a few hours in the unheated dome. Tinguely, whose somatic reactions are peculiar—he is often prostrated just before a surge of prodigious labours, as though, a friend says, he needed " a kind of pain before he can create"—insists that he was never sick a moment while working on "Homage." Almost everyone else remembers that he had a high fever for several days. In any case, toward the end, he was working almost around the clock, scarcely bothering to eat or sleep. He made tow more small constructions, self-propelled, and designed to break off from the main machine as it perished. The first had a giant motor and a two-foot Klaxon mounted on four baby-carriage wheels. The second, also on wheels, consisted of the cable drum and the oilcan, from which sprouted a wire with a corner of the American flag attached to it. This was tested in the museum lobby the night before the performance. While Tinguely and Klüver stood in rapt attention, the little cart rolled back and forth across the polished floor with an uncertain, jerky motion, its arm tapping a mach rhythm on the oilcan and its bit of flag waving bravely. This oddly appealing mechanism was supposed to roll away from the dying parent machine and drown itself in the reflecting pool of the garden, where Maillol's monumental nude female figure "The River" would preside over its demise.

Because the show was scheduled for early evening, Tinguely decided at the last moment to paint the entire construction white, in order to make it more clearly visible. He also confided to Peter Selz that he wanted "Homage" to be very beautiful, so that people watching it would feel dismayed when it began to destroy itself. ("I had no idea how beautiful it was going to be," Selz said later. "You had a real feeling of tragedy that that great white machine couldn't be preserved somehow.") Tinguely worried for fear painting it white might make it *too* beautiful, but he reassured himself that this danger would be

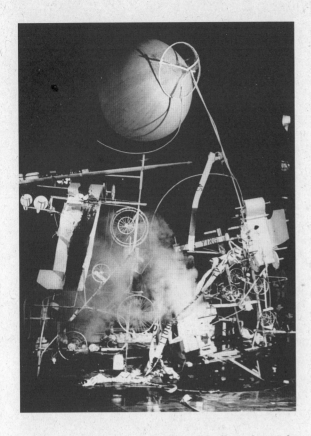

hats passed the Fifty-fourth Street wall and stopped to look into the garden, where workmen were struggling to move Tinguely's creation from the dome to the central court. The workmen kept slipping and sliding in the wet slush, and there were accidents. The Addressograph machine was damaged. Tinguely became tense. In his black boots, open storm jacket, and two-day-old beard, he looked like a Cuban revolutionary, and for the first time his spirits seemed a trifle subdued.

Robert Rauschenberg, the New York neo-Dadaist painter, showed up early, bringing a device he had made called a "money thrower." (Tinguely had suggested to several New York artists that they contribute to the master machine, in a sort of Bauhaus effort, and Rauschenberg, whose "combine paintings" are in some ways even farther out than Tinguely's creations, had promised to add a mascot.) This took the form of two heavy springs held in tension by a thin cord, with silver dollars inserted between the coils; when the cord was disintegrated by flash powder, the springs would fly up and scatter the silver dollars. Rauschenberg waited patiently for several hours to have his money thrower connected. "I felt privileged to be able to hand him a screwdriver," Rauschenberg says. "There were so many different aspects of life involved in that big piece. It was as real, as interesting, as complicated, as vulnerable, and as gay as life itself."

After a great deal of searching, Billy Klüver had managed to fill a request of Tinguely's for several bottles full of powerful chemical stinks. He arrived carrying these gingerly, and set them down near the partly assemble machine. Klüver also brought several containers of titanium tetrachloride, for making smoke, several previous methods having proved unsatisfactory. He asked Tinguely if it was all right to put the containers in the bassinet. Tinguely said it was. Time was running so short that decisions were being made on the spur of the moment.

Georgine Oeri, a New York art critic and teacher who had grown up in Tinguely's home town of Basel, came by to wish him luck. She found him in a state of momentary despair. He told her he had been trying to explain to the workmen that they must find a way to paint the snow black, so it would not detract from his white machine. The workmen had grown very fond of Tinguely (the day after the performance he gave a party for all of them in the

averted when the meteorological balloon burst from its overdose of compressed air and descended limply over it. Museum employees and officials pitched in to help with the painting. The excitement of the event had spread to everyone connected with the museum, including Alfred H. Barr, Jr., the Director of Museum Collections, who wrote, in a deMille-like museum broadside, about Tinguely's "apocalyptic far-out breakthrough, which, it is said, clinks and clanks, tingles and tangles, whirs and buzzes, grinds and creaks, whistles and pops itself into a katabolic Götterdämmerung of junk and scrap. Oh, great brotherhood of Jules Verne, Paul Klee, Sandy Calder, Leonardo da Vinci, Rube Goldberg, Marcel Duchamp, Piranesi, Man Ray, Picabia, Filippo Morghen, are you with it?"

Doomsday, a Thursday dawned gray and wet. The temperature, which had been below freezing for the for the three weeks that Tinguely had been at work on the machine, rose slightly and a light snow that had been falling since the previous night turned into a cold rain, which kept up intermittently all day. Over on Fifth Avenue, the St. Patrick's Day parade bravely drummed and blared its way uptown. Hordes of high-school children in green cardboard

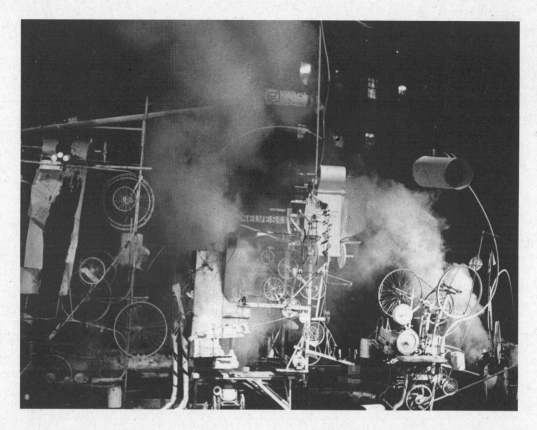

boiler room of the museum), but at this point they were convinced he had lost his mind. Oddly, although they spoke no French and Tinguely very little English, he and they never had the slightest trouble understanding each other.

Tinguely found that the Klaxon on the small carriage did not work. Robert Breer went off in search of another. The museum people suddenly became concerned about the garden's marble flagstones, and everything stopped while the workmen set wooden blocks under the machine. Toward five o'clock, a sizable crowd began to gather in the garden, despite the rain. Invitations had gone out to two hundred people, including Governor and Mrs. Rockefeller, specifying that "the spectacle will begin at 6:30 and will take approximately 30 minutes," but many came early, and many others who had not been invited came, too. The cafeteria facing the garden was full of spectators, and an N.B.C. camera crew was setting up lights and cameras to film the event. Outside the museum's main entrance, on Fifty-third Street, a German sculptor named Mathias Goeritz was handing out copies of anti-Tinguely manifesto. ("STOP the aesthetic, so-called 'profound' jokes! STOP boring

us with another sample of egocentric folk art…. We need faith! We need love! WE need GOD!") Tinguely had given up trying to have the snow painted black.

Bree returned with a Klaxon that he had bought fro a dollar from a scrap dealer on Tenth Avenue. Tinguely substituted it for the defective one. He also checked the arm of the big meta-matic and adjusted the roller. At one point, Klüver picked up a metal ring from the slush and asked Tinguely what it was for. Tinguely said he didn't know. He was calmer now, working steadily but without haste or tension, and seemingly unaware of the gathering crowd. At six o'clock, Kluver finally got a power line out to the machine, and they began connecting the circuits. Breer accidentally turned on a fire extinguisher that was concealed inside the piano, but managed to turn it off before anyone noticed. At six-thirty, they were still working on the machine. The crowd now filled the garden, standing patiently in slush that was nearly ankle-deep, under a fitful rain. Apartment dwellers on Fifty-fourth Street, across from the garden, were waiting at their windows. Some of the spectators in the garden were growing restless. David Sylvester, a British art critic, made a conspicuous departure, saying, "I don't like tuxedo

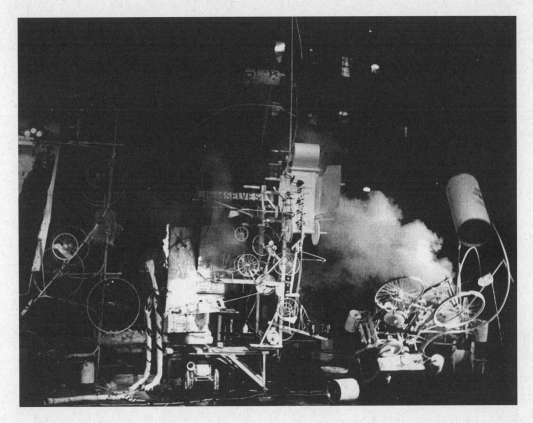

Dada." Two noted Abstract Expressionist painters followed him, muttering angrily. Kenneth Tynan, the theatre critic, was asked by a reporter to make a statement. "I'd say it was the end of civilization as we know it," Tynan replied cheerfully.

The big orange meteorological balloon was inflated and raised to the top of its mast. It looked like the moon rising, and the crowd hushed expectantly. Half an hour more went by while Tinguely and Klüver dashed back and forth between the dome and the machine. At seven-twenty, nearly an hour after the event had been scheduled to begin, Klüver discovered that they had neglected to saw through one leg of the machine. He sawed it quickly. The creation phase was now completed. The machine stood twenty-three feet long and twenty-seven feet high, its white, dripping structure cleanly outlined against the dark evergreens behind it, its eighty bicycle wheels poised for action. The destruction could now begin.

"At seven-thirty I was finished," Klüver wrote in his subsequent log of the event. "On va?' 'On va,' said Jean. He looked as calm as if he were about to take a bus. Not once did we go over and check everything. The end of the construction and the

beginning of the destruction were indistinguishable." Klüver put in the plug, the machine gave a convulsive shudder, rattled and immediately broke down. The belt driving the piano mechanism had slipped off its wheel as soon as the motor started up. Klüver tried frantically to fix it, his fingers numb with cold. "Laisse-moi faire, Billy!" Tinguely called out. A blown fuse was replace. The piano started to play again but other belts had jumped off and only three notes were working.

The big meta-matic clanked into operation. Instead of rolling down past the paintbrushes, though, the paper rolled itself up the wrong way and flapped derisively atop the machine; Tinguely had accidentally reversed the belt when he was attaching it to the painting arm. When he saw what had happened, he grabbed Klüver's arm and pointed, doubling up with laughter. From that moment on, it was clear that the machine would proceed about its destruction in its own way, but the audience, unaware that Tinguely's machines hardly ever work as they are supposed to, gave a collective groan.

What happened next was pure, vintage Tinguely. Thick, yellow, strong-smelling smoke billowed from the baby's bassinet, where Klüver had put the

tintanium tetrachloride, and was caught by the blast form the powerful fan that had been supposed to blow the metamatic painting toward the audience. Having waited an hour and a half to see the show, the spectators now found themselves enveloped in a choking cloud that completely obscured their view of the machine. They could hear it, though. Most of the percussion elements were working splendidly, and the din was tremendous.

When the smoke finally cleared, the machine could be seen shaking and quivering in all its members. Smoke and flames began to emerge from inside the piano, which continued to sound its melancholy three-not dirge; a can of gasoline had been set to overturn into a burning candle there. The radio turned itself on, but nobody could hear it. Rauschenberg's money-thrower went off with a brilliant flash. An arm began to beat in sepulchral rhythm on the washing-machine drum. At this point, the bottles of strong-smelling liquids were supposed to slide down from their rack and break, but the strings holding them failed to snap. The meteorological balloon refused to burst—there was not enough compressed air in the bottle.

The second metat-matic worked perfectly, producing a long black painting that immediately wound itself up again. The two texts unrolled, but the horizontal one began to sag, instead of winding itself up. "Do you remember that little ring you picked up and asked about?" Tinguely shouted to Klüver. "It was to hold the paper roll-up!" The vertical text had finished unrolling, and its loose end hung teasingly over the burning piano. Tinguely was beside himself with wonder and delight. Each element of his machine was having its chance to be, as he said later, "a poem in itself." A photographer took his picture standing in front of the machine, arms outspread, smiling, with the words "Ying Is Yang" on the horizontal text just above his head.

The piano was really blazing now. "There is something very odd about seeing a piano burn," Goerge Staempfli has since said. "All your ideas about music are somehow involved." For the museum authorities, a good deal more than ideas about music was involved. They had not anticipated a fire, and were understandably sensitive on that subject in view of the museum's second-floor fire the year before, which had destroyed almost two hundred thousand dollars' worth of paintings. The concealed fire extinguisher was supposed to go off at the eighteenth minute, but the flames had spread

through the whole piano and burned out a vital connection. Black smoke poured from the machine. With a limping, eccentric motion, the small suicide carriage broke away from the main machine, its flag waving. Then it sopped. Tinguely helped it along tenderly toward the pool but its motor was too weak, and it never got there. The addressograph machine started up, thrashing and clattering. It had been too badly damaged in transit, though, and it fell over after a minute or so, stone dead. Brilliant-yellow smoke flashed now began going off all over the machine.

Some twenty minutes after the start of the destruction, the resistors in the sawed-through supports began to melt the joints. The mechanism sagged but did not collapse entirely, because some crossbars at the bottom stubbornly refused to give way. The other small carriage suddenly shot out from under the piano, its Klaxon shrieking, and smoke and flames pouring from its rear end. It headed straight for the audience, caromed off a photographer's bag, and rammed into a ladder on which a correspondent for Paris-*Match* was standing; he courageously descended, turned it around, and sent it scuttling into the N.B.C sound equipment. Tinguely suddenly began to worry for fear the fire extinguisher in the piano would explode from the heat and he wanted firemen to put out the blaze. Klüver found a fireman in attendance, who seemed to be enjoying the show. He listened to Culver's pleading and then, with apparent reluctance, signalled to two museum guards, who ran out with small extinguishers and applied them to the piano fire. The audience booed the men angrily, assuming that they were spoiling the show. A *Times* photographer who went inside the museum a few minutes later overheard the fireman talking to headquarters on the telephone. "There are these machines, see," he was saying, "and one of them is on fire, but they tell me it's a work of art, see, and then this guy tells me *himself* to put it out, see, and the crowd yells 'No! No!'"

On of the guards ran into the museum and returned trundling a big extinguisher, with which he doused the piano and the surrounding machinery. He was furiously booed. The audience had seen everything go wrong, and now, it seemed, it was to be denied the machine's climactic act of self-destruction. More boos, interspersed with a few cheers, attended the final anticlimax as the fireman and the two guards attacked the sagging machine

with axes, knocking down the piano, the big meta-matic, and the mast that held the balloon. At the end, though, there was a rousing cheer for the dying monster. The crowd descended on the debris for souvenirs and managed to add to the general discomfort by breaking every one of the stink bottles. But if the audience felt frustrated, the museum authorities were in a state approaching shock; some of them were so angry about the fire that they refused to attend a reception held at George Staempfli's following the event. As Phillip Johnson, a trustee, said later, "It was not a good joke."

Not everyone agreed with Johnson. The newspaper reviews were mixed, most of them treating it as a crazy stunt that failed to come off. There were so few downright hostile reactions that the *Nation* was moved to comment sourly, "This is what social protest has fallen to in our day—a garden party." The only critic (aside from Dore Ashton, in a later article) to write about "Homage" at any length was the *Times* John Canaday. Although he called the show a "fiasco," he saw the machine as "an object of bizarre attraction, if not of classical beauty," and a "legitimate work of art as social expression, even if it pooped a bit." Returning to the subject in a Sunday column, he said that the machine was at lease honest in its destructiveness, and the Tinguely himself "deserved a nod of recognition for an elaborate witticism on a subject of deadly seriousness, man's loss of faith."

That sort of interpretation was fine with Tinguely, and so were all the others. To him, the machine was anything that anyone said it was – social protest, joke, abomination, satire – but, in addition, it was a machine that had rejected itself in order to become humor and poetry. It was the opposite of the skyscrapers, the opposite of the Pyramids, the opposite of the fixed, petrified work of art, and thus the best solution he had yet found to the problem of making something that would be as free, as ephemeral, and as vulnerable as life itself. It had evolved, after all, "in total anarchy and freedom," and he had been as surprised as any other spectator by this evolution. All the unforeseen accidents and failures delighted Tinguely. The fact that only three notes of the piano worked moved him deeply. As he said afterward, "It was very beautiful, I thought, and absolutely unplanned that one part of the piano should continue to play for almost fifteen minutes while the rest was being consumed by fire—those three notes still playing in the midst of the fire, calmly, sadly, monotonously, just those three. Many people told me afterward that for them it was a terrible thing. One woman told me later that she had wept, she found it so sad. It *was* sad, in many respects. It was also funny. I laughed a great deal while it was happening. I was the best spectator. I had never seen anything like that."

PLEASE STOP!

STOP the aesthetic, so-called "profound" jokes! STOP boring us with another sample of ego-centric folk art! All this is becoming pure vanity!

Today it is Jean Tinguely who wants to make us believe that his HOMAGE TO NEW YORK is leading us to a "wonderful and absolute reality". But we discover that nothing has happened since the decisive moments of Dada. It is still the same miserable, neurotic reality which fortunately never became absolute. It is not true that what we need is to "accept instability". That is again the easy way. We need STATIC VALUES!

Of course it is difficult to believe, since GOD was declared dead. It became easier to live without GOD, without cathedrals, without love. Nonconformism is easier to face than the Bible; functional vulgarity easier than cathedrals; sex easier than love. And — as the easy way became fashionable — our whole modern art is in a sad situation.

It is a fact that man is not made only to rationalize. Man is also made to believe. When man believes, he becomes able to do more important work.

We need faith! We need love! We need GOD! GOD means life! We need the very definite laws and commandments of GOD! We need cathedrals and pyramids! We need a greater, a meaningful art! We do not need another easy self-destruction.

Be consequent! Honor the tradition of Hugo Ball! Go forward and make the decisive, the most difficult step of Huelsenbeck's NEW MAN: From Dada — to faith!

Responsible for the text: Mathias Goeritz